THEN & NOW

GREER

OPPOSITE: Efird's was one of the many small chain stores with operations across upstate South Carolina from the World War I era through the 1940s. The young shopper crossing Trade Street is unidentified. (Courtesy of Dot Howard.)

GREER

Ray Belcher and Joada P. Hiatt

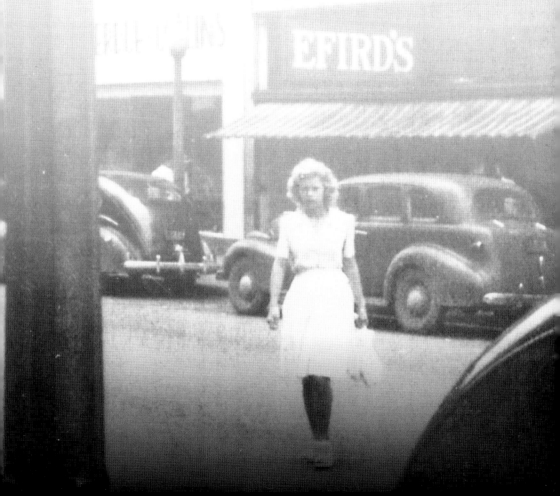

In memory of my parents, Elizabeth and Joseph Palmer.

—*Joada Palmer Hiatt*

For my girls.

—*Ray Belcher*

Library of Congress control number: 2008924298

Published by Arcadia Publishing
Charleston SC, Chicago IL, Portsmouth NH, San Francisco CA

Printed in the United States of America

For all general information contact Arcadia Publishing at:
Telephone 843-853-2070
Fax 843-853-0044
E-mail sales@arcadiapublishing.com
For customer service and orders:
Toll-Free 1-888-313-2665

Visit us on the Internet at www.arcadiapublishing.com

ON THE FRONT COVER: The depot of the Piedmont and Northern Railroad, an electric passenger train known locally as the P&N, was completed in late 1913. (Courtesy of Greer Heritage Museum.)

ON THE BACK COVER: This 1922 picture shows the congregation in front of the Concord Methodist Church, which was built the year prior on the corner of Connecticut Avenue and Duke Street. (Courtesy of Ann Withrow.)

CONTENTS

ACKNOWLEDGMENTS

The authors wish to thank the Greer Heritage Museum for providing many of the pictures used in the book. Also special thanks go to the people of the Greer area who were willing to share their pictures and tell their stories.

Pictures were provided by the following people and institutions: Mary Robertson, Jerry Jackson, Karolyn Taylor, Ann Withrow, Dot Greer Howard, Kenneth Mullins, Marshall James, Bessie Taylor, the Suber family, Nella and Jeff Howell, Greer First Baptist Church, David and Debbie McCoy, Beatrice Whitman, Henry Sammons, Minnie Grubbs, Debbie and Terry Dobson, and the Jean M. Smith Library of Greer.

The authors also appreciate the work that Dr. Rose Marie Cooper did in documenting and collecting historical information about the buildings in Greer's historic downtown district.

The photographers for the project were Ray Belcher and Alan Hiatt. The known historic photographers were Charles W. Drace, ? Beijun, and ? Solesbee, who left their names visible on some of the older images. Unless otherwise noted, all images are from the authors' collections.

INTRODUCTION

Greer, South Carolina—the little city with a big future—straddles the Greenville-Spartanburg county line. Although its neighbors—Spartanburg to the east and Greenville to the west—are larger, Greer has always been a progressive small city. In 1891, there were about 300 residents, but by the beginning of the 20th century, the population had doubled to 648. During that first decade, four textile mills and their accompanying villages were built on the outskirts of town. Two African American communities also skirted the city limits, adding to a much larger community than the census recorded. By 1950, the census counted 4,443, a number that still did not include the Sunnyside Community or Victor Mill Village. Today the city of Greer has grown to more than 28 square miles, with its limits crawling southward across Interstate 85 and a growing population of more than 23,000.

Greer has always been well located. When Airline Railroad, later the Southern, chose James Manning Greer's farm as the site for its depot, it was just a matter of time until people moved close to the source of transportation. William Terry Shumate, who bought Greer's land, subdivided it into lots, and the city of Greer was incorporated in 1876.

A second railroad, the Piedmont and Northern (P&N), laid tracks through Greer in 1913. Today two railroads, the Norfolk and Southern Railroad and the CSX, still travel the two tracks through the heart of the city. On Greer's doorstep is the Greenville Spartanburg International Airport. Two major highways, Interstate 85 and Highway 29, also travel through Greer. Just as the textile industry came to Greer as an excellent location in the early 1900s, automotive manufacturer BMW and its related industries sought out Greer in the 1990s.

Cotton built Greer. The railroad brought fertilizer and supplies to local farmers, who brought bales of cotton to a strong local market that often paid better than the Greenville market. Money in farmers' pockets meant money saved in local banks and spent on Trade Street. Locally grown cotton also supplied the textile mills. Not only did the mills draw in local cotton, but they also drew in tenant and small-acre farmers, broke and tired of eking out a living farming, who were glad to have jobs and houses in the mill villages. Thus it is fitting that this history begins with the interrelated industries of farms and mills.

Agriculture and textiles fueled Greer's growth in the early part of the 20th century. Saturdays were a big day in Greer when farmers arrived. Families from the textile mill villages that were within walking distance of downtown Greer also patronized the commercial district along Randall and Trade Streets. In the early 20th century, buildings made from bricks created at the works along Poplar Drive, replaced wooden buildings along Trade Street. Most of the buildings in downtown Greer today were constructed during a three-decade period starting in the early 1900s. Valuing its history, Greer has been proactive in preserving these same buildings. In 1997, the National Park Service designated the 7.8-acre downtown area of Greer as a historic district on the National Register of Historic Places.

Anchoring the downtown historic district on each end of East Poinsett Street are the new city hall and the police and court building. Like a lantern, the lights through the new glass entry of the police and court building shine the way into downtown. Behind the new city hall, the old City Park, built in 1934, found new life as a gathering place for citizens. The year 2008 saw the completion of these outstanding projects, which indicate that Greer is looking to the future while cherishing its past.

Over the years, Greer has represented the small-town American spirit. While it cannot boast of famous names and faces, it represents the American Dream—people working hard, educating their children, expressing their faith in God, and always striving for a better future for themselves and their neighbors. This pictorial history uses images that show where the residents of Greer worked, shopped, lived, learned, and worshipped, and where they go about those same activities today. These pictures epitomize a century of life in Greer—a good place to live.

CHAPTER 1

FARMS AND MILLS

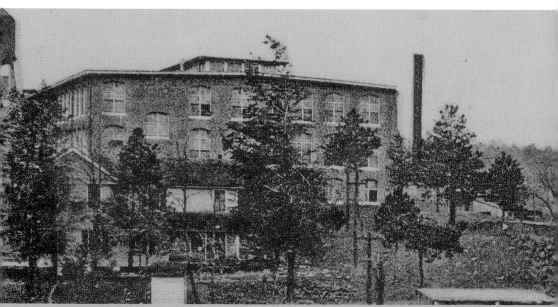

In 1833, Thomas Hutchings built South Tyger River Manufactory, a spinning mill known as "Hutchin's Factory." In the 1860s, it became Cedar Hill Factory and later Arlington Cotton Mill. In 1904, Apache Mill, shown here, was built. J. P. Stevens closed the plant in 1981.

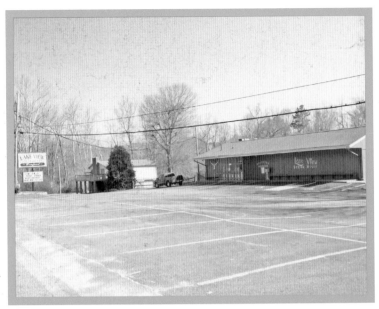

In 1814, Phillip and Eliza Bruce Mosteller planned their mill. After Phillip died of fever, Eliza ran the mill with the help of her son David. Also on the site was a cotton gin, a post office, and a magistrate's court to serve the Ansel community. The mill, shown here, operated until 1970. Today the Lakeview Steak House occupies the site, and diners look out on the waters of the South Tyger River that once powered the mill. (Then image courtesy of Greer Heritage Museum.)

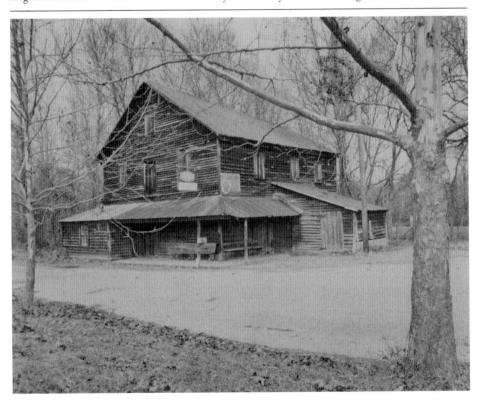

FARMS AND MILLS

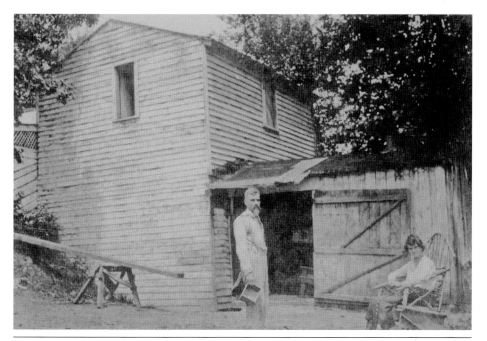

Walter Hillary Suber built this corn mill in 1908 on land that his father, James Suber, had received as an early land grant. Pictured from left to right are Hillary Suber and his wife, Linnie James Suber. Today the mill is little changed. The "visiting room" on the right where one sits to chat with Jim Suber and his wife, Linda, the fourth generation of Subers to operate a corn mill, has been replaced. The Subers grind white corn meal and grits. (Then image courtesy of the Suber family.)

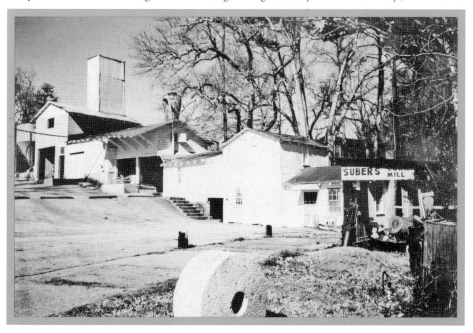

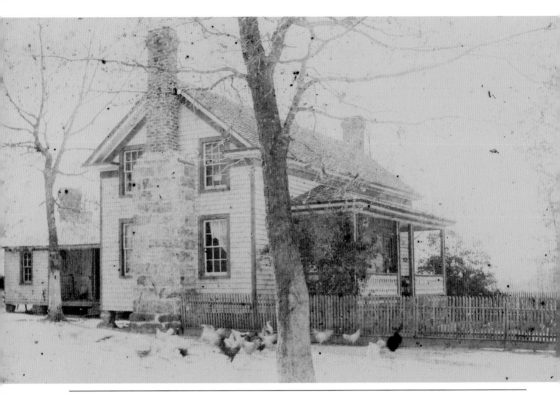

Tommy and Mamie Ballenger, brother and sister, farmed near Greer for many years. Living in the 1898 home built by their father, they represented the simple life as it was once lived in early Greer. After their deaths, the land was sold for a housing development. Pictured here are some of the homes that now cover the land that Tommy once plowed with his handmade plow and mule.

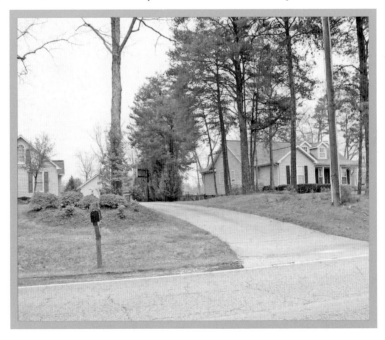

FARMS AND MILLS

David D. Davenport opened the Greer Cotton Seed Oil and Fertilizer Company in December 1896. Oliver Smith managed the business for Davenport, who realized good profits from the venture. Even the farmers were glad to be paid for seeds that had once been considered worthless and dumped on the ground. The building near the railroad tracks was torn down, and the land remains vacant.

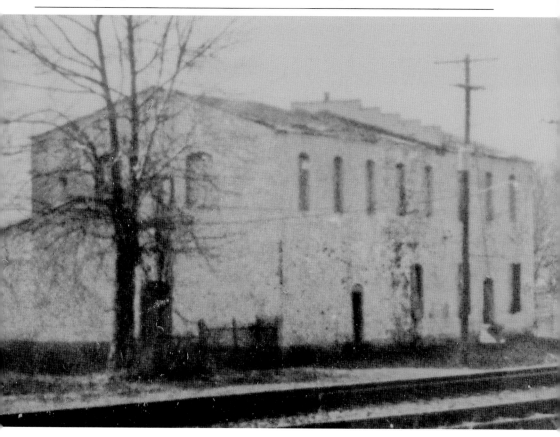

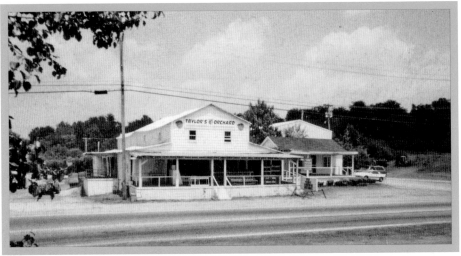

James P. Taylor, an early peach farmer, had five acres in production in 1898. In 1917, his son Earle began his own orchard and, by 1920, was shipping peaches by rail to northern markets. The peach shed (shown here) has had additions to the original 1923 building. It was used by E. Richard Taylor Jr., a third-generation peach grower, until he retired in 1996. Today it is used by Fisher's Orchards as a state-certified roadside market. (Then image courtesy of Richard Taylor.)

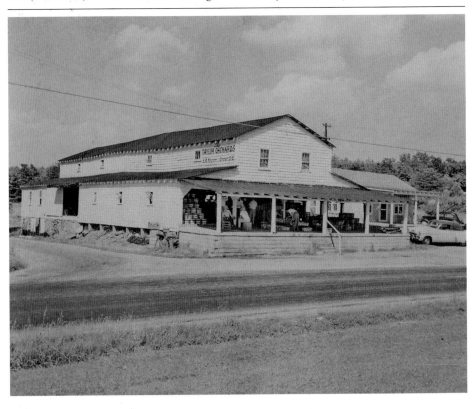

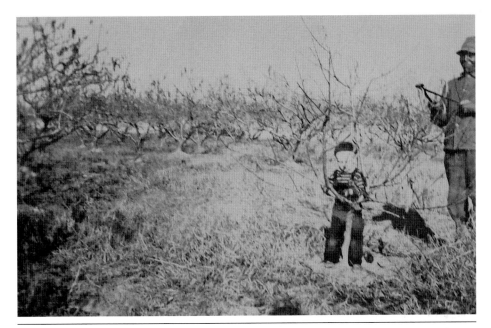

Palmer Dillard planted 5,000 Elberta peach trees in 1923. Three years later, his orchard produced its first crop. The 1950s photograph of an unknown child shows the orchard in spring as the peach trees bloom. Today Palmer's son Lem Dillard still owns Dillard Farms along South Buncombe Road. During the summer months, the peach shed is full of teenaged workers packing peaches for satisfied customers who sample peach ice cream in Dillard's Ice Cream Parlor. (Then image courtesy of Ann Withrow.)

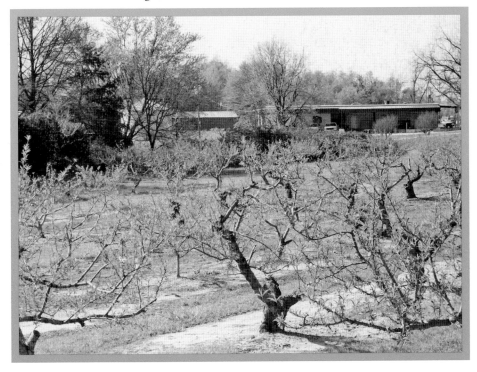

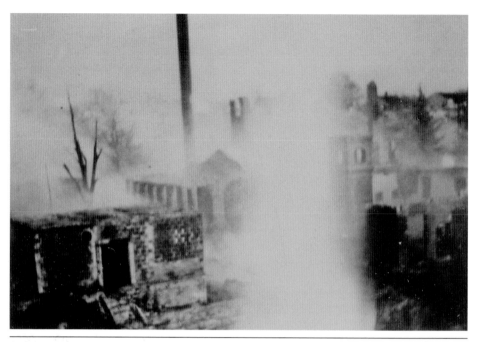

Pelham Manufacturing Company was chartered in 1880 by Jackson and Arthur Barnwell. In 1882, the name was changed to Pelham Mills. A small textile mill, Pelham had the distinction of having the mill itself in Greenville County and its village mainly in Spartanburg County. In 1935, the mill closed.

The vintage photograph was taken in 1941 when the mill (seen to the right) was burning. Today Highway 14 has been widened with a new bridge crossing the Enoree River. (Then image courtesy of Minnie Grubbs.)

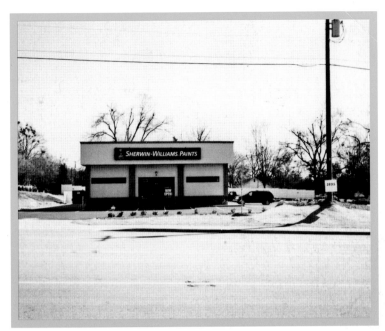

The Pelham mill provided a community center for the women to meet, chat, and sew. In this early 1900s picture, the women, who met to quilt and embroider, include Corrie Hendrix, Ola Grier, ? McKown, Elmie Dempsey, Jessie Poole, Mary Greer, Frances Davis, Drucilla Hawkins, Edna Vaughn, ? Corn, Lillie Green, Oma Davis, and Hassie Dempsey. The building is long gone, and a new Sherwin Williams Paint Store was recently built on the site. (Then image courtesy of Dot Howard.)

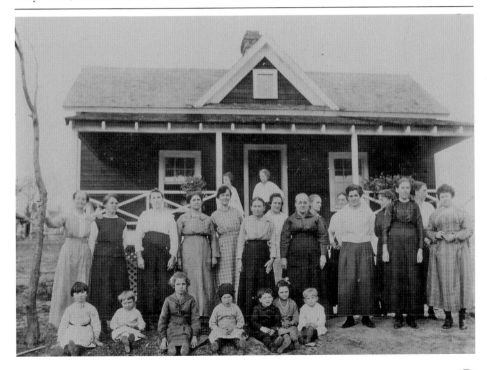

On April 10, 1914, the funeral procession for Ansel Hawkins stopped for a photograph in front of one of the Pelham mill village houses on F Street. Pictured from left to right are John D. Wood, the funeral director; and pallbearers John Rector, Saxby Smith, Charlie Davis, Harvey Hawkins, Will Jones, and Boyd Davis, members of the Odd Fellows. Today kudzu covers the empty lot where the mill house stood long ago. (Then image courtesy of Dot Howard.)

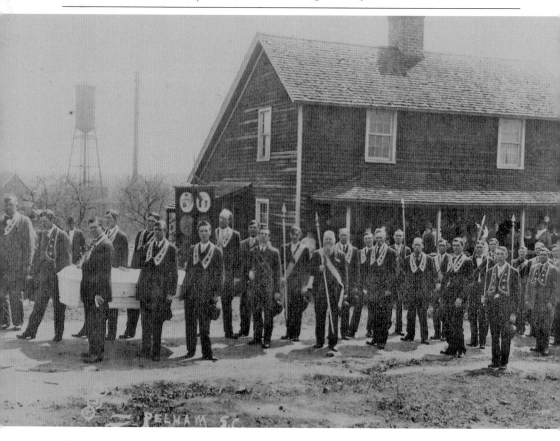

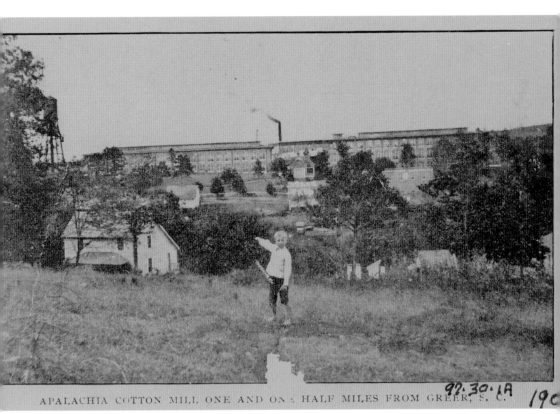

APALACHIA COTTON MILL ONE AND ON HALF MILES FROM GREER, S. C.

92.30.1A
190

A child from the Apalache Mill village points toward the textile mill in the early 1900s. The house shown in the picture is typical of the wood-framed houses built by the mill for the workers. Apalache Mill village had a union church, a school, and a company store within easy walking distance for its employees. The photographer was Charles Drace. Today the mill is the site for the development of condominiums. (Now image courtesy of David McCoy.)

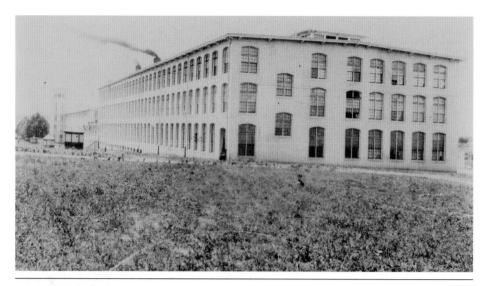

Victor Manufacturing Company was chartered in 1895 with W. E. Burgess as president. By 1897, all looms were operational, and the first houses for workers were being built. The largest textile mill in Greer, Victor became one of the model mills in the state. Victor ceased textile production in 1982 but was immediately refurbished as Victor Center, the financial headquarters for a portion of the J. P. Stevens Company. Victor Center closed in 1986; while under demolition, the mill burned in 2006.

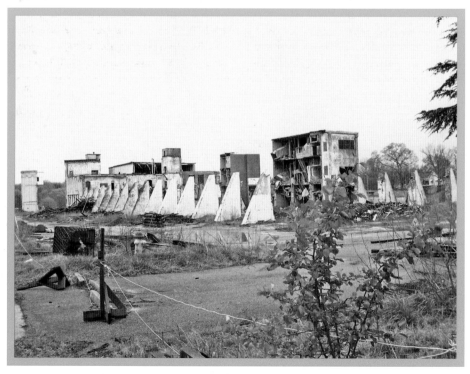

Construction on Franklin Mill began in the summer of 1900, only five years after Victor Mill was chartered. Built on property that had belonged to the Westmoreland family, it produced coarse yarns, operating 5,000 spindles. During World War II, it became Victory Mill. Heritage Industries, the last owner, sold the property in 1972. The Greer Commission of Public Works demolished the old mill and built its operations center, which is shown here on McCall Street.

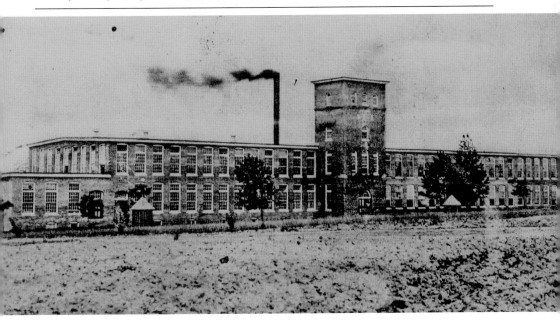

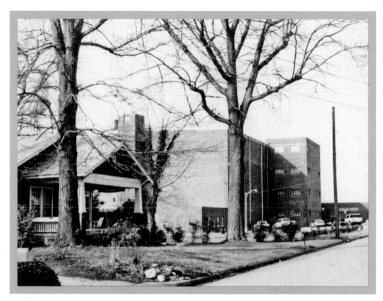

In 1909, John Robinson founded the Greer Manufacturing Company. Two years later, he sold it to the Parker group, which became part of the Victor Monaghan Company. In 1946, J. P. Stevens bought the mill. When J. P. Stevens sold the mill to Delta Woodside in 1986, the mill was making apparel fabric. The last textile mill in Greer to close in 1993, the building today is used by CDS Ensembles, Inc., which makes comforters, dust ruffles, and pillow shams.

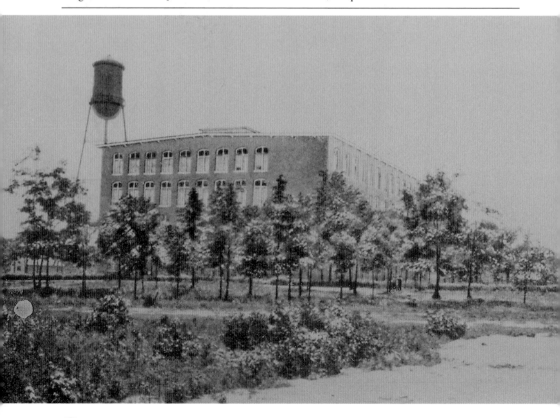

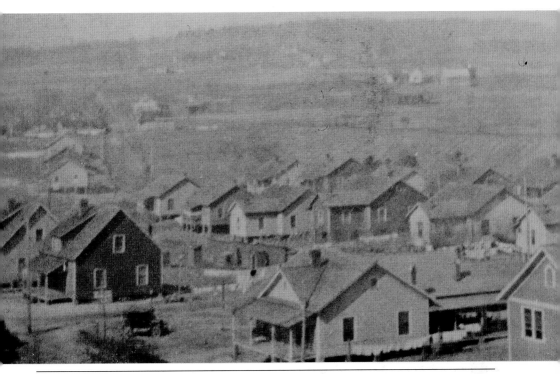

The Greer Mill was surrounded with small houses, ranging from shotgun-style homes consisting of three rooms in a row to two-story homes for large families. After J. P. Stevens bought the plant, the houses were sold, beginning in 1951. A new weave room was added to the west end, and a new YMCA was constructed at a cost of $3 million. The house visible in both pictures now has been updated with white siding.

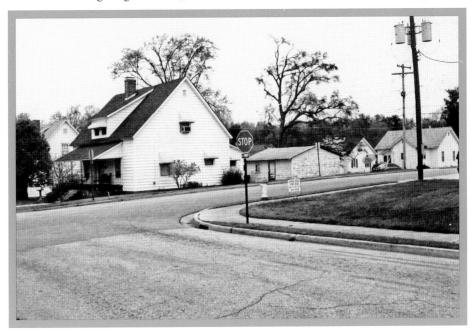

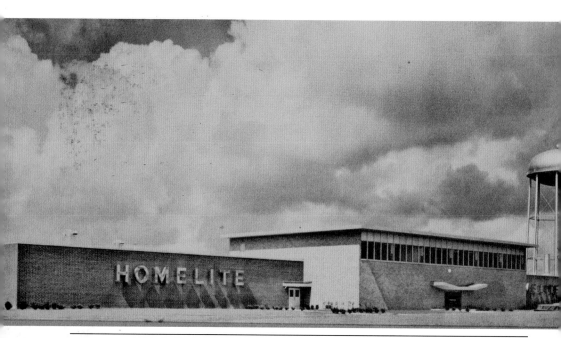

Homelite began operation on July 1, 1959, in this manufacturing plant on South Buncombe Road after moving from Port Chester, New York. The Greer plant made engines for riding mowers, outboard motors, and lightweight chain saws. Later owner John Deere closed the plant in 2003. Associated Packaging, Inc., a corrugated sheet plant owned by Bill Dorris, occupied the building in 2006. (Then image courtesy of Greer Heritage Museum.)

STREETS AND RESIDENCES

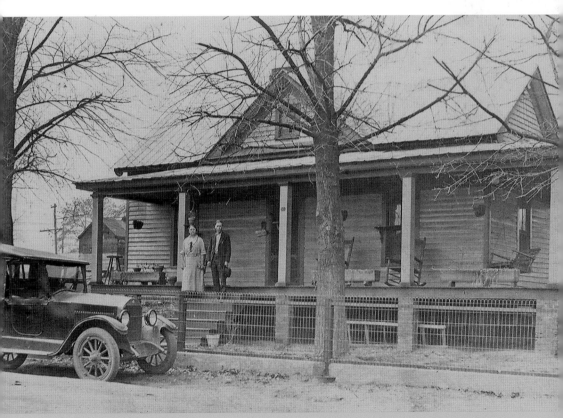

Will and Maggie Stroud Stewart lived on North Line Street, which today delineates the Greenville-Spartanburg county line. Originally it was part of the Old Indian Boundary line that was later used for the county line. Neighbors can leave their county by merely walking across the street. (Courtesy of Greer Heritage Museum.)

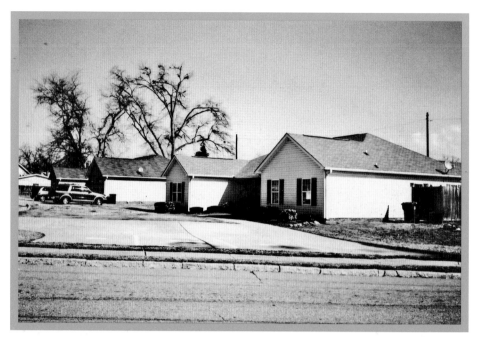

This 1899 photograph of a house in Victor Mill village is typical of the homes built for textile workers. Pictured here is the Wilson family, from left to right, Charlie Wilson, ? Wilson, and Annie Wilson. The typical mill house, made of unpainted weatherboarding, was box-shaped with a sloping roof and front porch. Today urban renewal has removed old mill houses and replaced them with duplexes such these shown above. (Then image courtesy of Ann Withrow.)

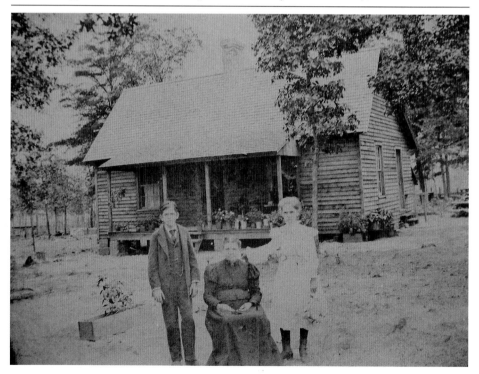

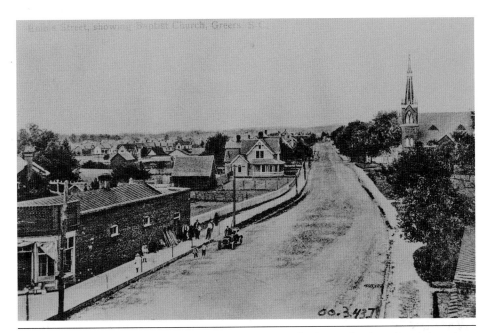

Emma Street, named for the wife of Dr. H. V. Westmoreland, was a fine residential street in early Greer. On the right, the First Baptist Church can be seen. This brick building, designed by architects Keating and Proffit, was finished in 1906 and was used until 1923. On the left side of the street can be seen the house that later boarded teachers. The street was later renamed West Poinsett. The police and court building under construction can be seen at the left. (Then image courtesy of Greer Heritage Museum.)

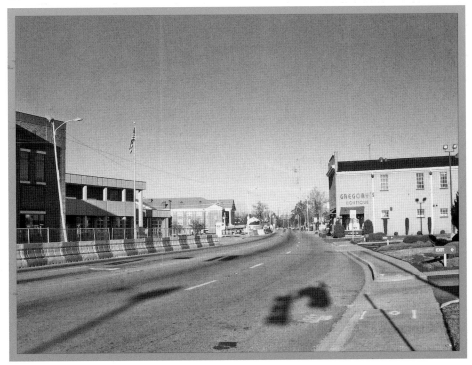

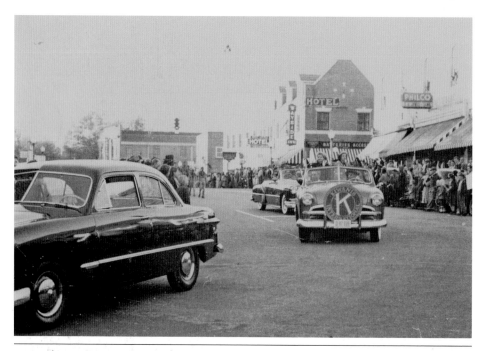

Parades have always been popular venues in Greer. The 1950s Christmas Parade shows the T. E. Jones furniture store where the Philco sign advertises. Also seen are the Wayside Inn on the corner and the Paget Chevrolet Dealership beyond it. Today the hotel and Jones's store are gone, and the building that once housed the Chevrolet dealership now houses Gregory's Boutique, a clothing store owned by J. W. Gregory since 1968. The business relocated to this building in 1975. (Then image courtesy of Greer Heritage Museum.)

This scene of Trade Street looking south shows Fay's Flowers in the corner building and the Firestone Store next door. The popular Graham Cash Company operated in a building built by Thomas Keating in 1932. Beside it is Beason's Jewelers. On the left side of the street, the Lanford Real Estate and Insurance sign is barely visible. Today dancers twirl around the old Graham Cash building in the Starlight Ballroom, and diners enjoy the Bin 112 restaurant next door.

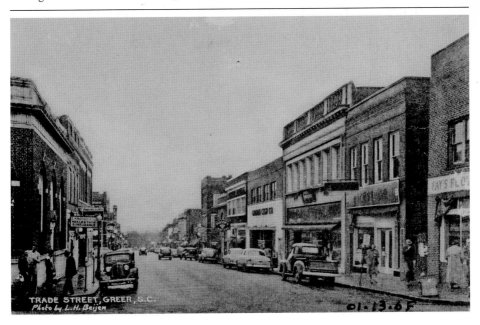

STREETS AND RESIDENCES

31

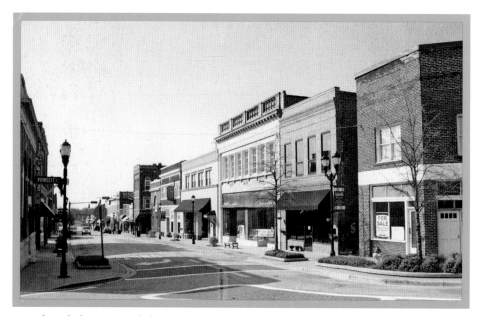

An early real photo postcard shows Trade Street as it extends from Ponder's General Merchandise Store. Long before paved streets, Trade Street stores had boardwalks to keep ladies' shoes free from the dust and mud of the street. Ponder left this store and became a local bottler and ice cream maker, offering his wares in a popular ice cream parlor on East Poinsett Street. (Then image courtesy of Greer Heritage Museum.)

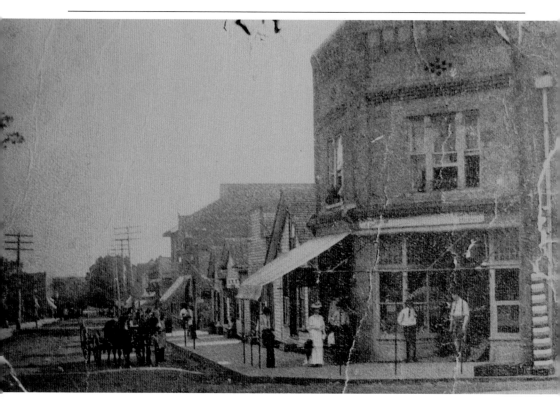

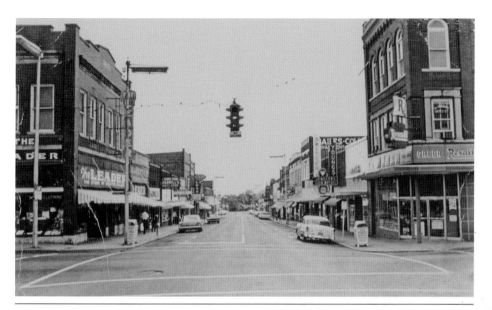

During the 1950s, Trade Street was a destination for shopping in stores such as Bailes Collins (midway on the right) and the Leader Department Store. Called the Bailey Building, the Leader was built in 1915 by T. E. Smith and was named for his wife, Fannie Bailey. Both the Leader and Bailes Collins stores sold clothing. The Leader closed in 1965. The last business to occupy the Bailey Building was Stewart's Furniture Outlet, which closed in 2007. (Then image courtesy of Greer Heritage Museum.)

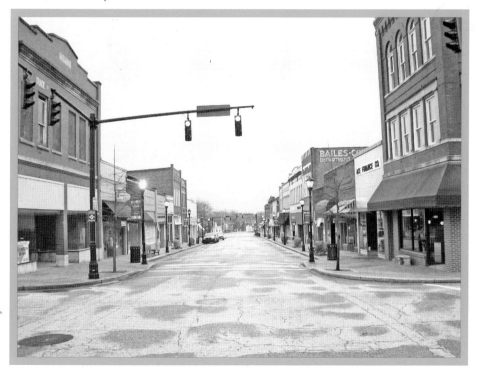

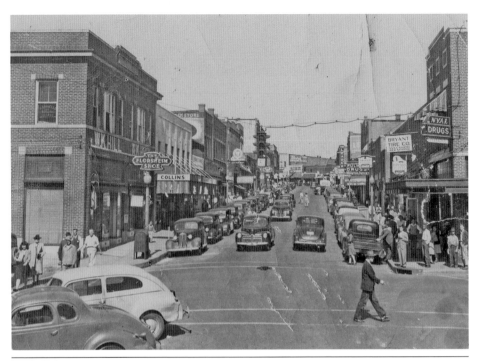

In the late 1940s and early 1950s, downtown Greer was a destination for farm families, residents of mill villages, and local citizens. This Trade Street scene shows the popularity of shopping in Greer on Saturday. On the left are the Hill and Collins stores, which sold clothes. Today Events at the Davenport offers party space, while Kim's Fabrics does business next door. The Collins store is now a mini-mall offering Lunch and Such Restaurant and Chelsea's Apparel Shop. (Then image courtesy of Greer Heritage Museum.)

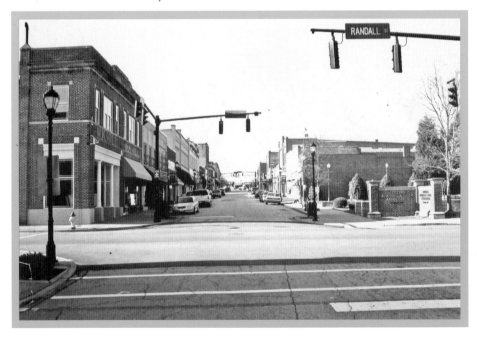

An early photograph of Victor Avenue shows a dirt road leading to the textile mill on the right. The water tower and chimneys of the mill dominate the skyline. On the left is the Methodist church and homes. For many years, the mill was the most prominent landmark on this street, but demolition and fire have left it in ruins. In a current scene, the paved city street passes the same house and church. (Then image courtesy of Jerry Jackson.)

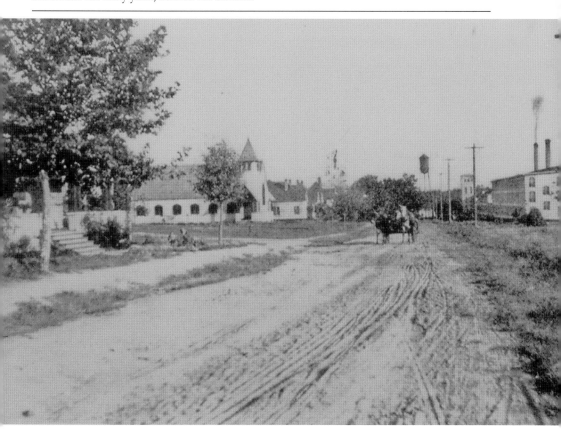

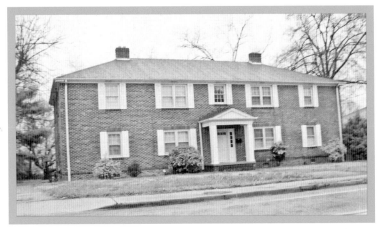

In 1901, the First Baptist Church built a new parsonage for its minister, the Reverend J. E. McManaway, pictured in front of the house. It was located at 307 West Poinsett Street, two blocks from the church. In May 1901, McManaway ended his term at the church, which began in 1896. Later the church would build across the street on the corner of Pine and West Poinsett Streets. Today Crowe Apartments, comprised of four units, sits on the spot. (Then image courtesy of First Baptist Church.)

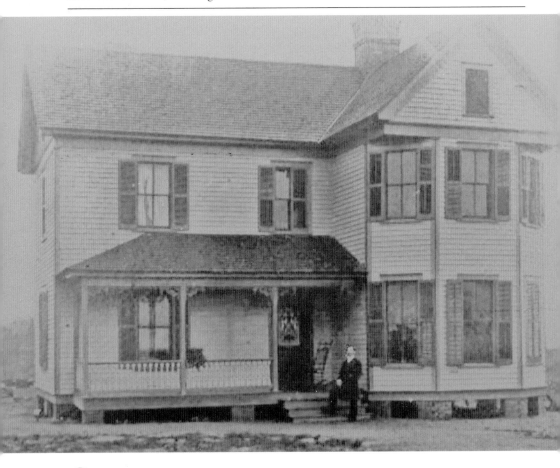

STREETS AND RESIDENCES

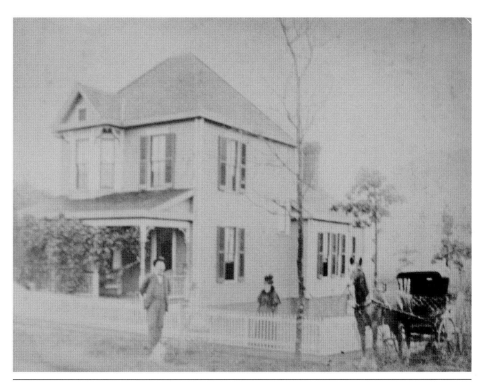

Charles W. Drace, an itinerant photographer from Pennsylvania, settled in Greer in 1896 and used his skills to document life in Greer and the surrounding area. He owned a photograph shop as well as the Grand Theatre. He is shown here with his wife, Fannie, in front of his home on West Arlington Avenue. The home stayed in the Drace family until 1977, when Nella and Jeff Howell bought it and restored it. They later added a family room at the rear. (Then image courtesy of Jeff Howell.)

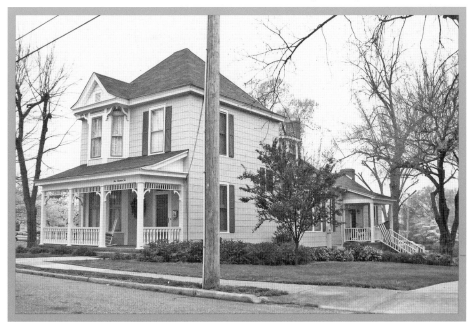

STREETS AND RESIDENCES

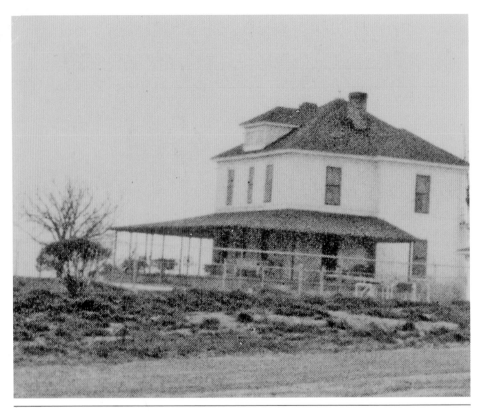

The sport of golf had appealed to local citizens since the 1920s, when a small course was established on Victor-Monaghan property near the Greer Mill. After World War II, interested citizens formed an association, which acquired property two miles north of Greer and built an 18-hole golf course. The Greer Country Club was built on the site of an old upland plantation. The old house was removed, and the clubhouse (shown here) was built on the site.

John A. Robinson was an American success story. Leaving the farm, he grew up in Greer and became a successful businessman who founded the Greer Manufacturing Company, commonly called the Greer Mill, in 1909. His home (shown here) was built in the early 1900s on South Main Street. Southern Home Insurance purchased the site for its offices. Since State Auto Insurance Company bought Southern Home Insurance, the company has continued using this building and expanding it over the old home site. (Then image courtesy of Smith Library.)

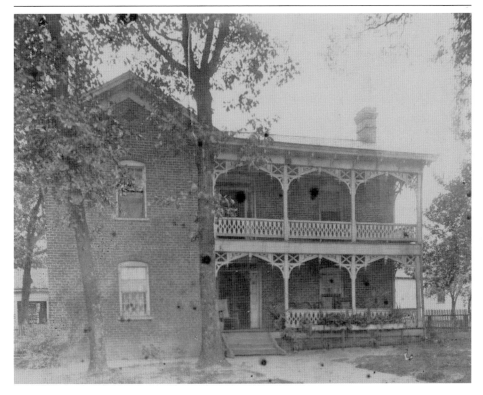

When this picture was taken in 1919, the first superintendent's home in the Greer Mill village was occupied by Claude Hemphill. It sat directly across from the mill on Robinson Street to enable the boss to respond at a moment's notice to emergencies. Hemphill, who was well liked by the workers, was called "Super" by the young and "Claude" by his peers. Today the site is a portion of the parking lot used by CDS Ensembles, Inc.

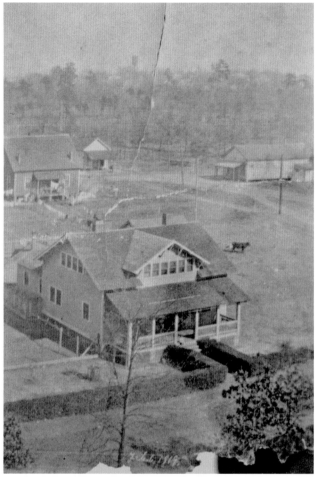

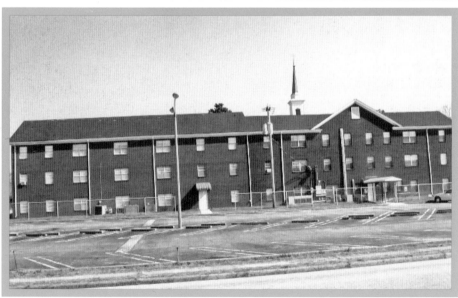

STREETS AND RESIDENCES

TRADE AND BUSINESS

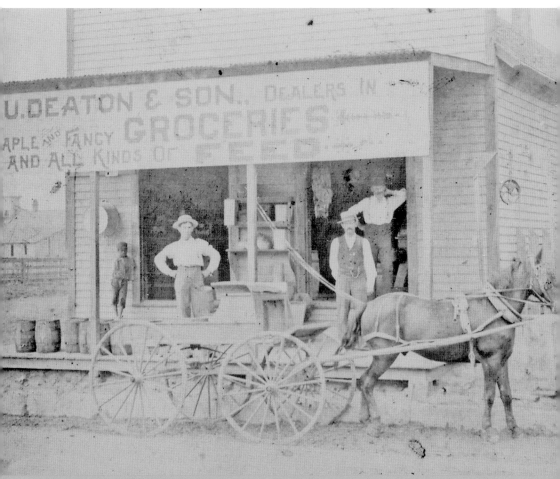

General stores, such as Deaton's, provided everything from nails to shoes. Located in the Blue Ridge area, it carried dry goods, hardware, and groceries for the farm families. With wagon transportation on poor roads, rural families welcomed small stores nearby to schools and churches. They were popular gathering places and often the sites of post offices. (Courtesy of Greer Heritage Museum.)

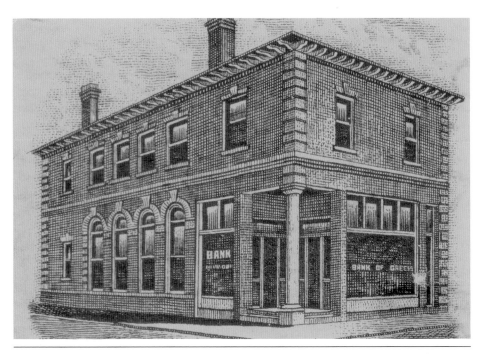

The first bank in Greer was organized in 1900 as the Bank of Greers. The building shown above on the corner of Trade and Victoria Streets was built in 1905. After several reorganizations, it became the Bank of Greer during the Depression and operated in the building shown below until it was acquired by United Carolina Bank in the 1980s, becoming a downtown branch bank. After BB&T acquired United Carolina Bank, it closed the historic building in 1997. (Then image courtesy of Greer Heritage Museum.)

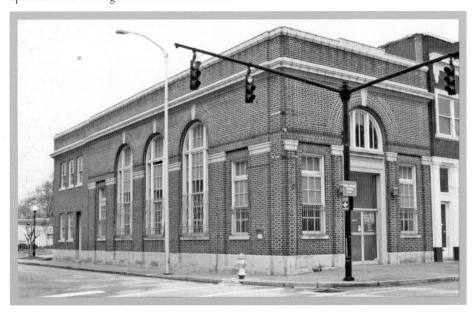

The Baswell Blacksmith Shop was located in the area behind the old Wood-Mendenhall Hardware between Trade Street and present-day Depot Street. This 1908 picture shows, from left to right, Tom Baswell; Jim Baswell, Tom's son, holding the horse; and Will B., Tom's brother. The bearded man and black man are unidentified. Wood's Mortuary was in front of the shop on Randall Street and used Baswell's services to shoe the horses that pulled the hearse. (Then image courtesy of Kenneth Mullins.)

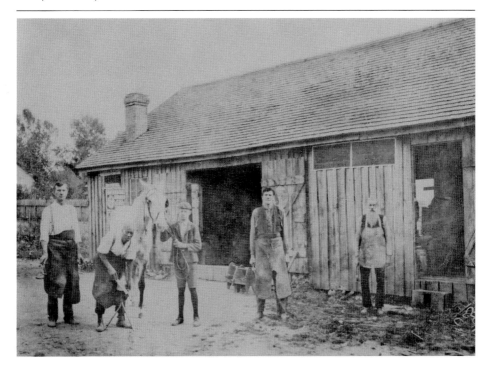

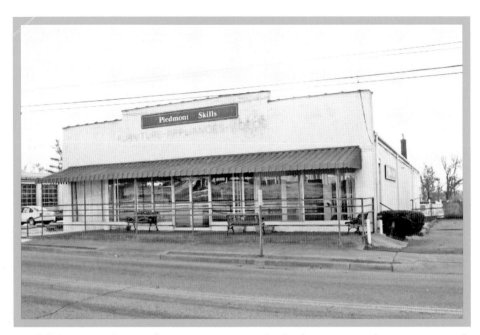

Founded by J. Harley Bonds, a prominent businessman and school board member, Bonds Furniture Store offered affordable furniture to the people of Greer. The building became the site of Piedmont Skills after Bonds moved his business to the developing center of commerce on Wade Hampton Boulevard (Highway 29). Piedmont Skills is a workshop for challenged adults, providing work and socialization at the center five days a week.

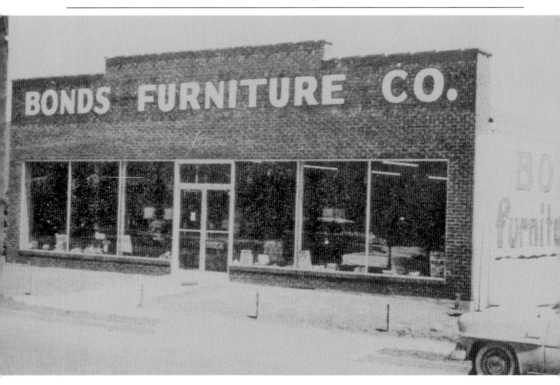

In 1874, John Carman bought lots in Greer, intending to move his blacksmith shop from O'Neal, but instead, he sent his oldest son, John Landrum Carman. Carman became a leading citizen, serving as a school board member and a deacon of the First Baptist Church. His brother David H. Carman worked with him and inherited the business when John died about 1897. The business operated for 45 years, but today the site, lying between the two railroad tracks, is vacant.

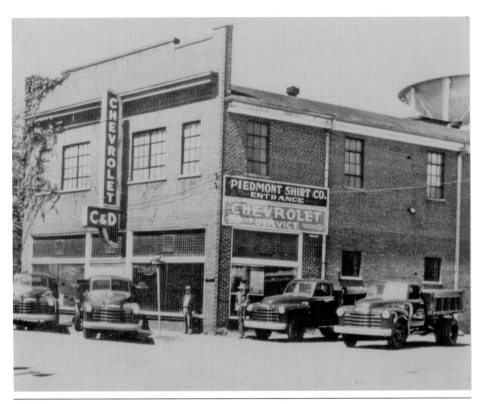

In 1927, partners J. C. Cunningham and R. D. Dobson organized C&D Chevrolet. In 1937, James Paget Sr. joined the dealership, eventually buying out the other partners. For some time, the Piedmont Shirt Factory operated upstairs. In 1964, with his sons as partners, Paget changed the name to Paget Chevrolet. Today it is Gregory's Boutique, a clothing store owned by J. W. Gregory since 1968. The present business relocated to this building in 1975. (Then image courtesy of Greer Heritage Museum.)

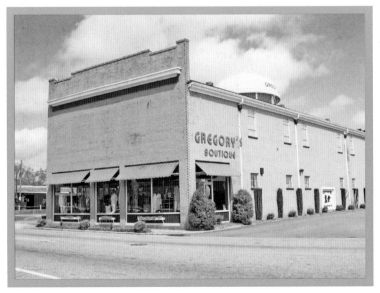

The Community Cash Grocery, a chain grocery store headquartered in Spartanburg, had three locations until it finally closed. Shown here is the first of three locations. The building had originally been Ballenger's Store and later housed the Poinsett Bakery. The scene shows the Greer High School Band Homecoming Parade in the 1950s. The city purchased the property and removed the buildings. On this corner today is the new police and court building. (Then image courtesy of Greer Heritage Museum.)

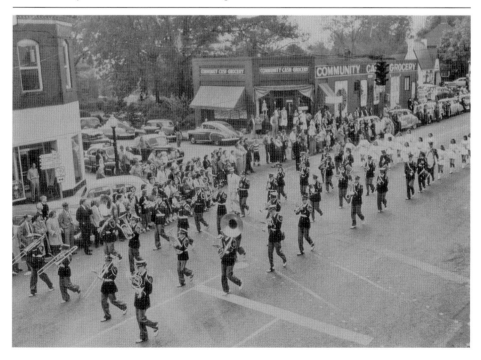

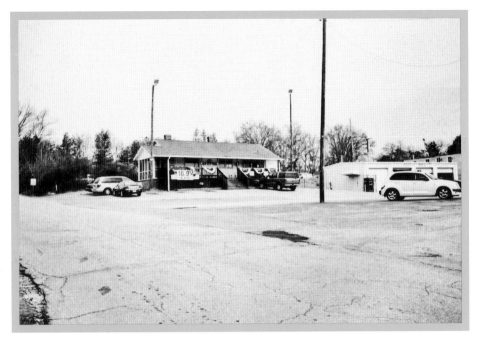

The Cotton Club was the place to be in the 1950s for a night of dinner and dancing. Sitting on a hill above Wade Hampton Boulevard, it was just a short drive out of town and was a popular place for holiday parties for garden clubs, civic organizations, and mill supervisors. The club burned after it closed, and today a used car lot sits just in front of the former restaurant building.

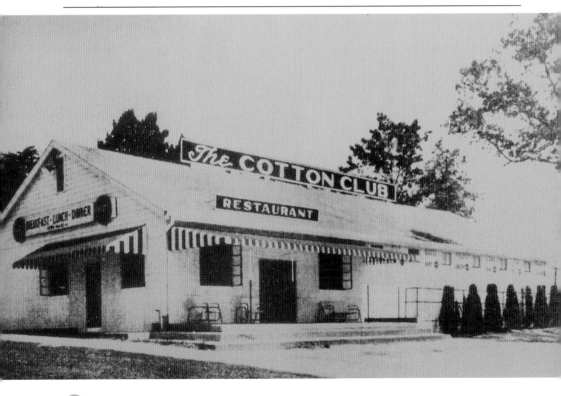

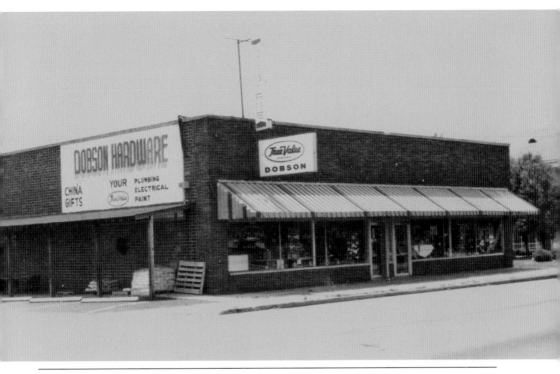

W. R. "Bill" Dobson learned hardware in the Sullivan-Eskew Hardware on Trade Street before opening his own store on the corner of South Main and East Poinsett Streets in 1945 in the former A. G. Howell Grocery. In 1963, Dobson moved to the building (shown here) that was once the Community Cash Grocery Store. Today his son Terry operates Dobson's Gifts and General Hardware on Wade Hampton Boulevard. The historical building is gone, and the site is a new downtown municipal parking lot. (Then image courtesy of Terry Dobson.)

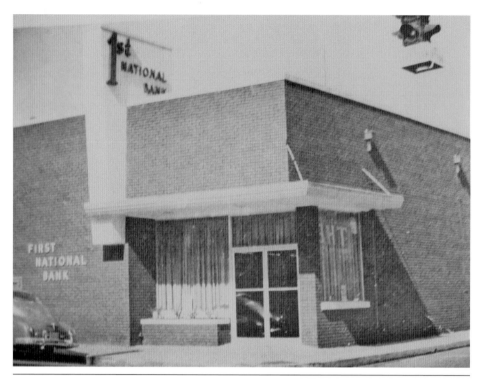

There have been two "First National Banks" in Greer, the first one operating from 1921 to 1930. During the late 1950s, a new bank was organized under the leadership of Dan D. Davenport, Marion Lanford, and William E. "Bill" Richardson, which operated in this building at 117 Trade Street. That institution was the last bank founded by Greer investors during the town's cotton era. Later Duke Power Company used it, but the building is now on the market.

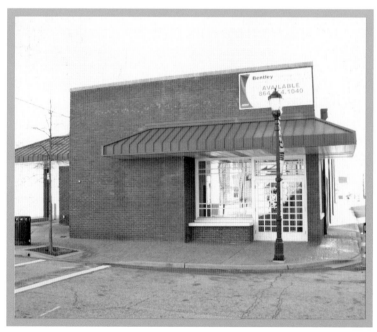

Charles Drace opened the first movie theater in Greer. By 1915, he owned both the Dixie, later called the Rialto, and the Grand Theatre, shown here in the 1940s when his son Bill owned it. The Grand once had live vaudeville shows and was a popular place on Saturdays. The theater closed in the mid-1960s, when it was no longer able to compete with the larger-screen theaters and drive-ins. Today there is just a space along East Poinsett Street where the building stood. (Then image courtesy of Greer Heritage Museum.)

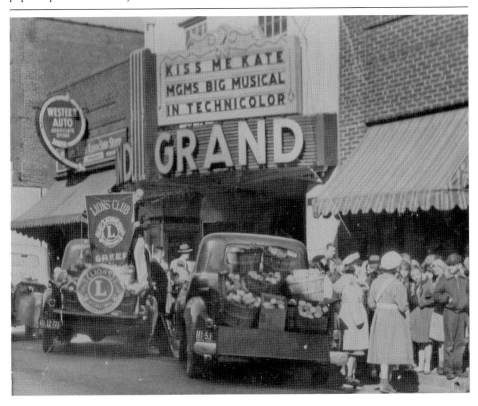

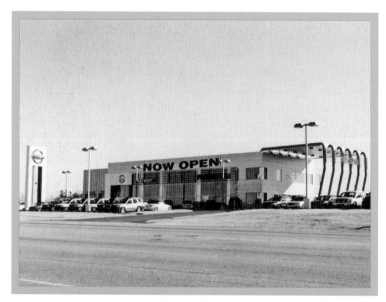

Greer's earliest motel dates from the post–World War II era, when only two boardinghouses, a camp site, and a tourist home catered to travelers passing through Greer. Located on Wade Hampton Boulevard, called the "Super Highway" or Route 29, it was well situated on the main thoroughfare for traffic to Atlanta, Georgia, via Greenville. It was removed, and the Nissan Dealership built this new facility there in 2007. (Then image courtesy of Greer Heritage Museum.)

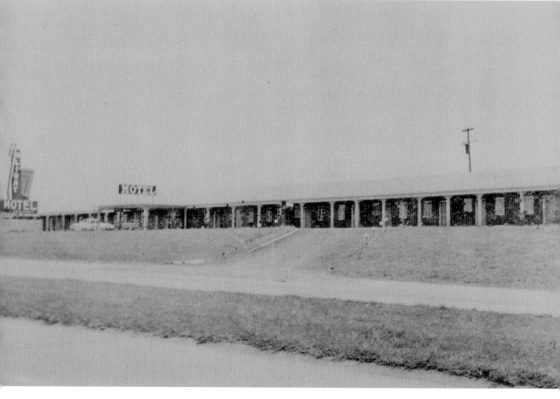

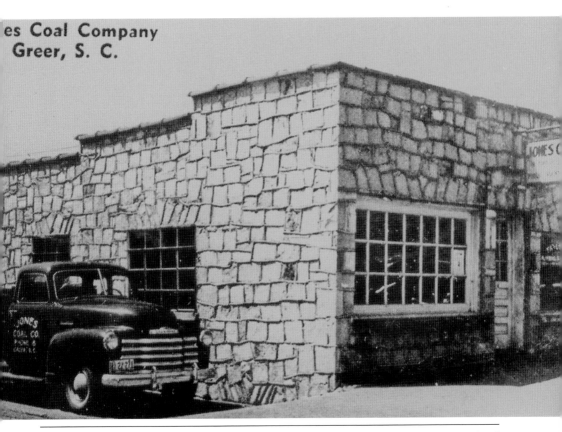

es Coal Company
Greer, S. C.

J. L. Jones was the founder of this business, which expanded to include moving and storage when the coal business declined. Since coal was still used for heating in the 1950s, the Jones Coal Company had steady business and operated until the 1970s.

Located at 314 Trade Street between the railroad tracks, the company could receive coal by rail. The increased use of natural gas diminished the need for this business. The building, which has been renovated, now houses Netta's Beauty Salon.

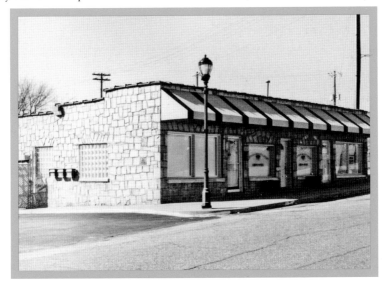

TRADE AND BUSINESS

In 1910, Dr. Robert Lee Marchant hired J. C.
Cunningham to construct a building on the
corner of Trade and Victoria Streets to house
the Greer Drug Company, later a Rexall store.
The only three-story building in downtown
Greer, it was designed by Thomas Keating and
cost $8,500. Doctors and dentists occupied
the upper floors. It remained a drugstore
until the late 1970s. On January 20, 2007,
Peter Tripp and Harold Baker opened Vintage
Jewelry in the historic building. (Then image
courtesy of Greer Heritage Museum.)

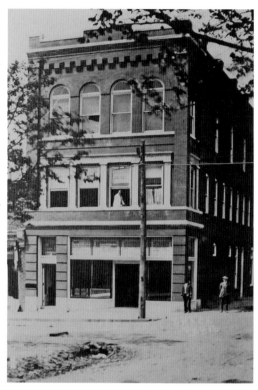

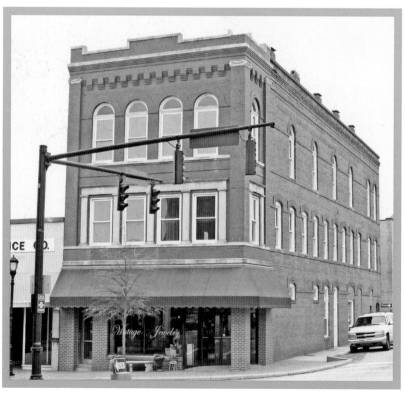

J. Walter McCarter opened a barbershop in a former drugstore (shown here) on the corner of Randall and Trade Streets and operated his businesses there for many years. His neighbors included the Sanitary Café and Miller Hardware. Located at 301 Trade Street, it was in front of the Piedmont and Northern Depot. In poor condition, the buildings along this block were razed, and a municipal parking lot was created. The old depot has been divided into retail spaces.

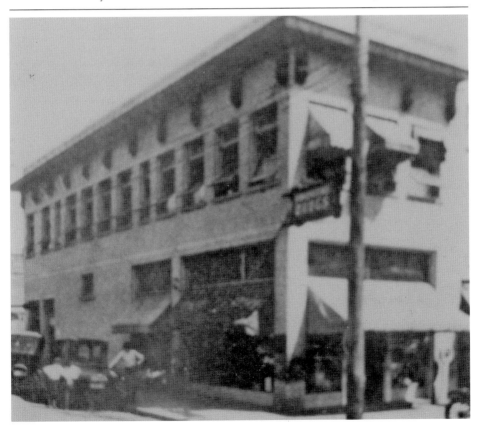

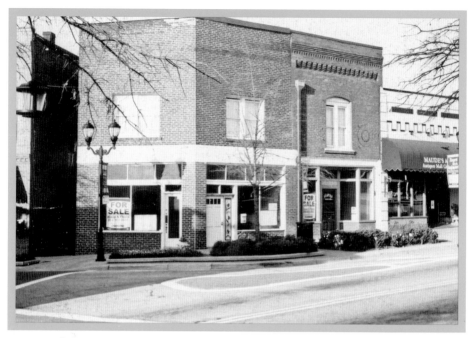

Rogers Brothers Market occupied the building at the corner of Trade and Poinsett Streets. It was a meat market. Pictured from left to right are Irb Rogers; Artemas Ertzberger, the butcher; and two unidentified young men. Next door was the Lunch Room. Recent owners have worked on the old building, which is currently for sale. (Then image courtesy of Mary Robertson.)

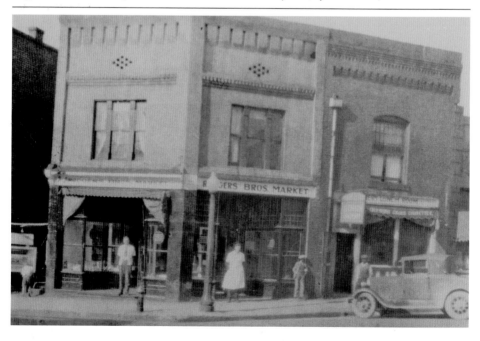

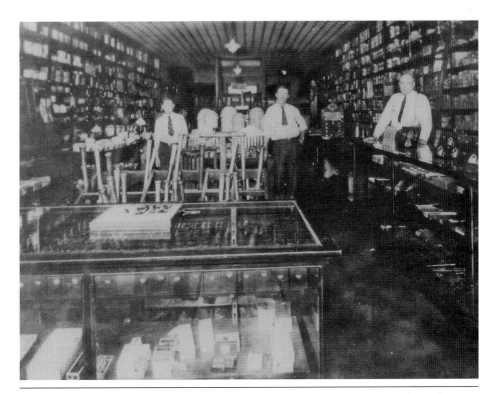

Around 1913, Mendenhall and Wood built this two-story building for a hardware store. Pictured inside the store in the early 1930s are, from left to right, manager J. B. Mendenhall, Dever E. Bailey, and Charles Graham McClimon Sr. Sullivan-Eskew bought the business and continued selling hardware, farm implements, and toys for many years. Today the Greer Heritage Museum occupies the historic building, which is now owned by Carolinda McClimon Robison, whose father worked in the store for many years. (Then image courtesy of Greer Heritage Museum.)

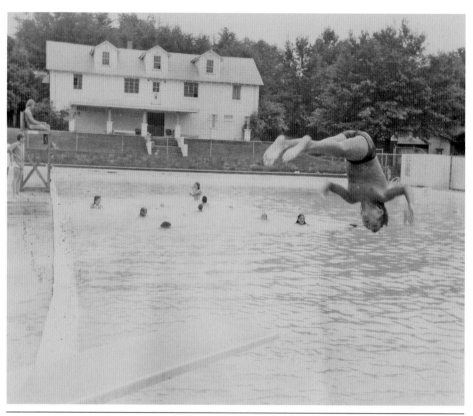

Tom Suttles opened a swimming pool on West Wade Hampton Boulevard on July 6, 1949. Affectionately known as "Suttles's Puddle," the pool was lit for night swimming. Suttles's Pool, which charged only 25¢ for children, was a popular place for local youth. In the late 1970s, the Greer YMCA used it and then closed it in the early 1980s. Today the Comfort Inn covers the pool site. (Then image courtesy of Greer Heritage Museum.)

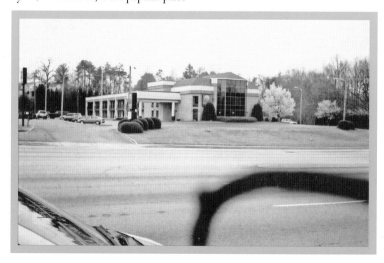

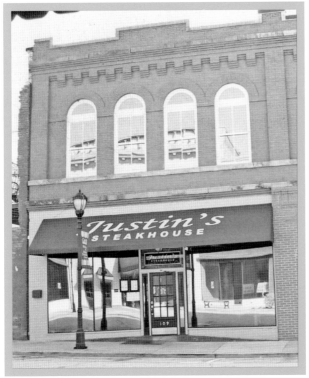

Thompson Hardware moved to this building on Trade Street. Later the *Greer Citizen* used the building in the 1930s, and the Book Exchange operated there in the 1980s. Today Justin's Steakhouse occupies the downstairs, while a private apartment graces the second floor. An outside stairway has been added to access the apartment, which features the original brick wall with the Chero-Cola sign advertising the earliest soft drink bottled in Greer. (Then image courtesy of Greer Heritage Museum.)

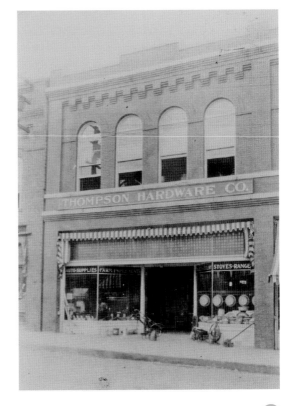

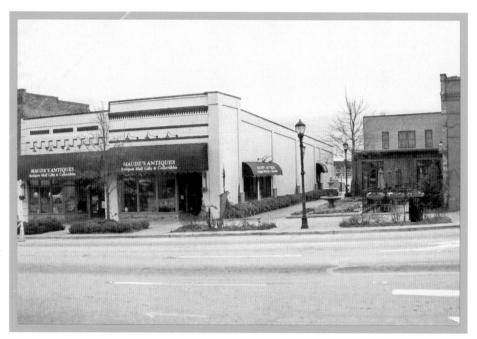

In 1907, Thompson Hardware became the authorized dealer for Ford automobiles. Vehicles were ordered from the manufacturer in the same way carriages and other horse-drawn devices had been ordered. On Thursday, December 2, 1909, Thompson received a load of automobiles, including a town car ordered by a Spartanburg doctor, a roadster, and a touring car. An old photograph shows these cars in front of Thompson's business. Maude's Antiques occupies part of the old hardware store. (Then image courtesy of Greer Heritage Museum.)

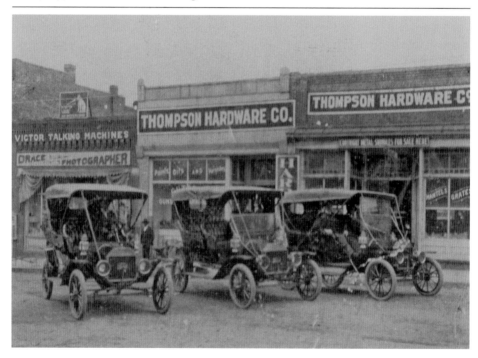

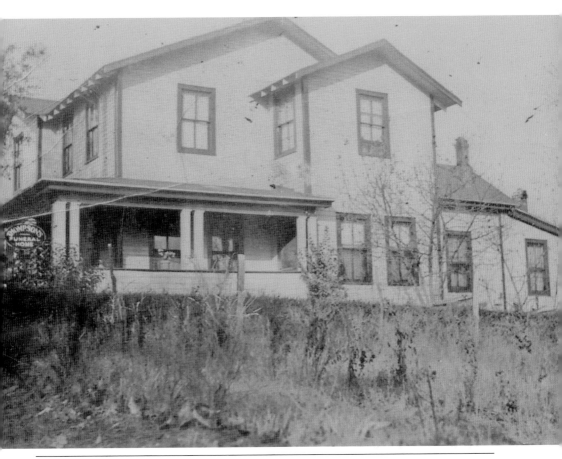

The Thompson Funeral Home, located at 122 Forest Street, was an African American funeral home located in the Needmore section of Greer. Blanche E. Thompson, also a seamstress, opened the business in 1932. After Thompson died on February 26, 1954, the family ran the business until 1956. Today a new home that is part of the revitalization of the neighborhood occupies the site. (Then image courtesy of Bessie Taylor.)

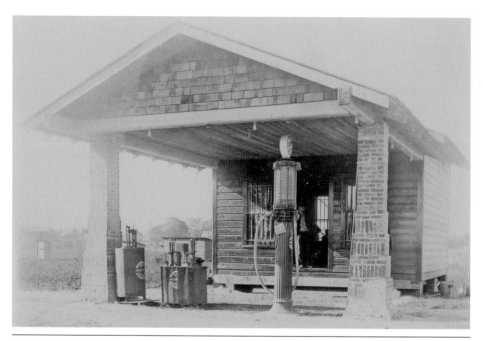

John Tooley operated Tooley's as a small general store during the 1920s in east Greer, where it thrived for more than 30 years along Arlington Road. After the general-store era, it was operated as a produce stand until after World War II. Today it is the site of an apartment complex called the Companion at Arlington. (Then image courtesy of Greer Heritage Museum.)

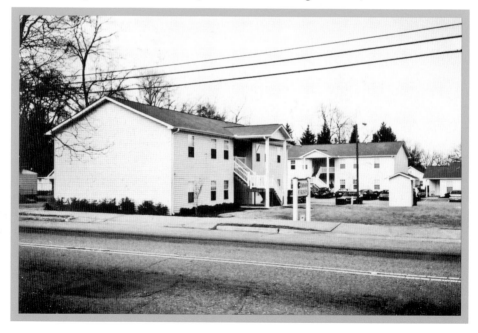

TRADE AND BUSINESS

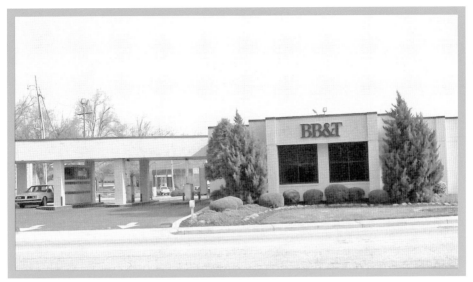

The Wayside Inn opened on December 17, 1929, under the management of Col. W. W. Marmaduke. The building, which cost $100,000, was designed to contain as many as 50 modest rooms, some with baths. The Queen City Coach Corporation provided Greer's first bus service, stopping at the hotel beginning on June 10, 1930. The Trailways and Greyhound bus lines later used the same facility as a bus depot for more than 50 years. Today BB&T has a branch bank on this historic corner. (Then image courtesy of Greer Heritage Museum.)

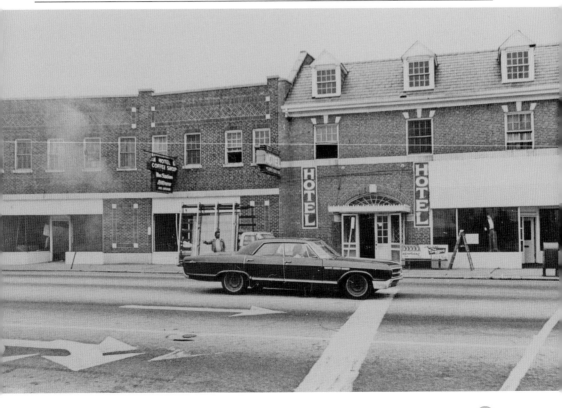

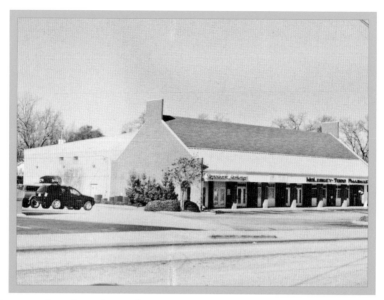

Winn-Dixie arrived in Greer during the 1950s. It was larger than any of the modest grocery stores there at the time and appealed to shoppers who wanted a variety of products at low prices. The image shows the second location of the four successive sites occupied before the chain closed its South Carolina stores. When Winn-Dixie moved to a larger store, McLeskey-Todd Pharmacy moved from a small East Poinsett Street store to this location, where it continues business on North Main Street. (Then image courtesy of Greer Heritage Museum.)

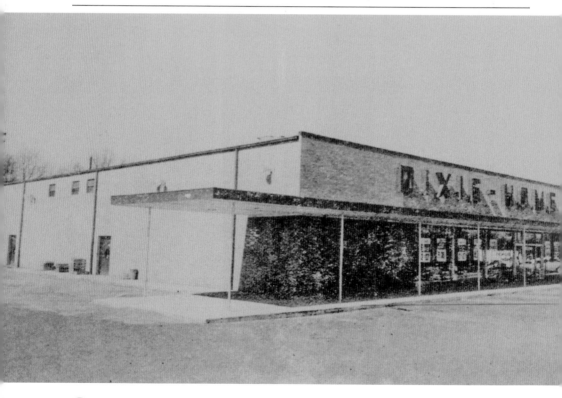

SCHOOLS AND INSTITUTIONS

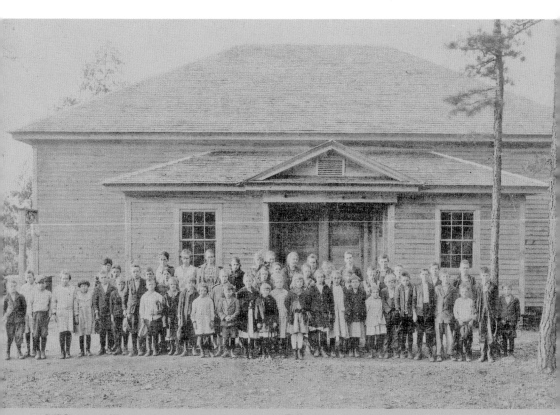

In 1896, the Ansel School operated as a one-room, one-teacher school located about two miles northwest of Greer. The Ansel community had been in existence since before the Civil War, with a post office located at Mosteller Mill. In the early 20th century, the Ansel community was designated as School District 9-I in Greenville County. (Courtesy of Greer Heritage Museum.)

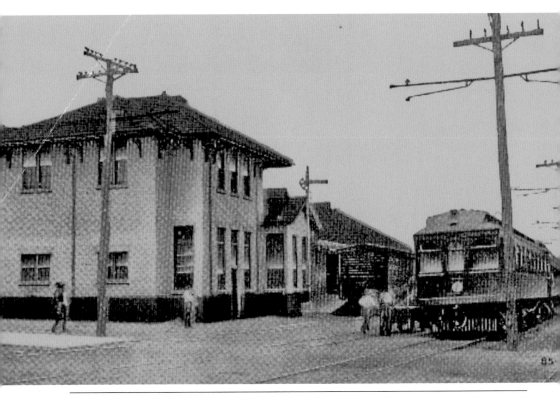

In the fall of 1913, the Piedmont and Northern (P&N) Railroad built a two-story brick depot and warehouse along its new tracks running through Greer. On March 23, 1914, the first passenger train stopped at the depot. It became a popular interurban, with 14 trains a day passing through Greer. The depot today is home to several small business. The building itself has been placed on the National Register of Historic Buildings. (Then image courtesy of Greer Heritage Museum.)

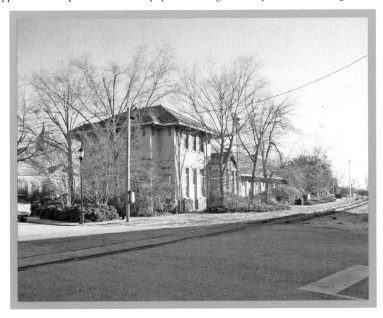

SCHOOLS AND INSTITUTIONS

When the Atlanta Richmond Airline Railroad, which was to become the Southern Railroad, laid tracks through Greer, the company purchased land for a depot and right-of-way from James Manning Greer. The pictured station replaced the original three-room depot that was once called "Greer's Depot" or "Greer's Station." With passenger travel on the wane, this depot was later razed.

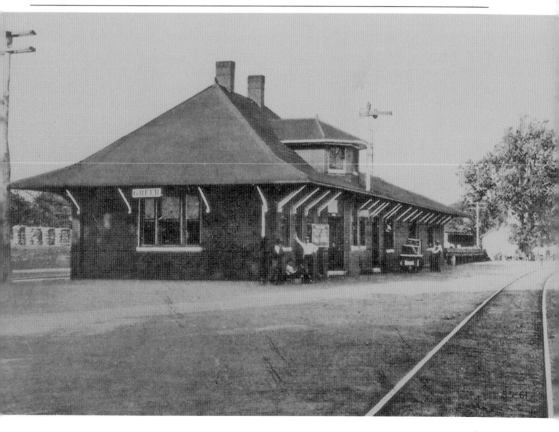

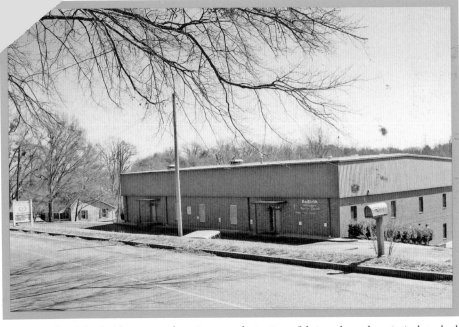

The Apalache School (shown in the vintage photograph) was built in 1933 and was used until 1970, when the students in the area were sent to the new Crestview Elementary School. The last principal, Elizabeth Howell McElrath, had the distinction of being the only principal to both attend the school as a child and teach there as an adult. Today the old school building is used by the Rebirth Missionary Baptist Church.

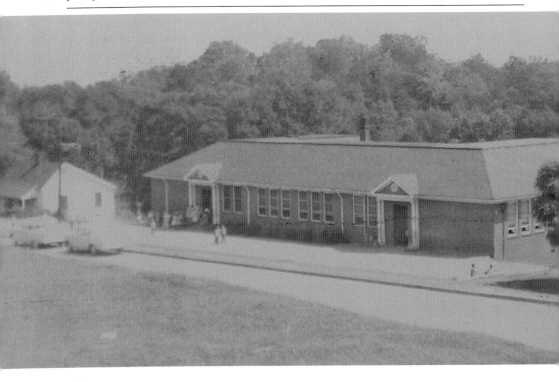

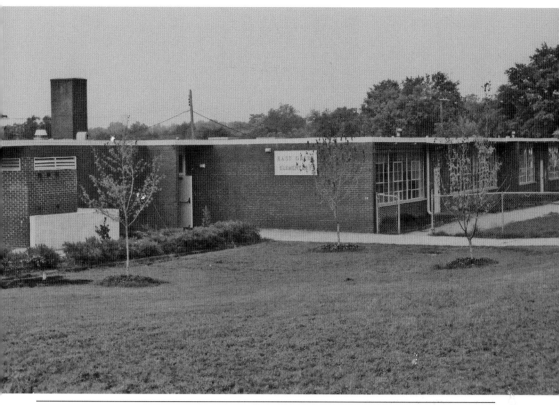

In 1954, Dunbar Elementary School was built on Morgan Street to replace the original wooden, Rosenwald-style school for the African American children of Sunnyside. During integration in 1972, Dunbar and Victor Mill School were merged, and the Dunbar School (shown here) was renamed East Greer Elementary. In 1999, it became a preschool facility. The new facility (pictured below) replaced the old building and was renamed the Dunbar Child Development and Family Learning Center to honor its historical roots. (Then image courtesy of Greer Heritage Museum.)

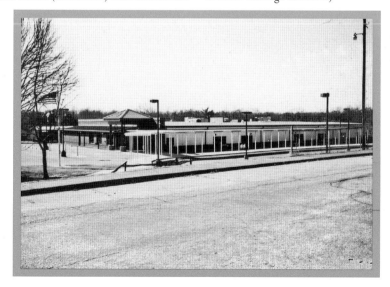

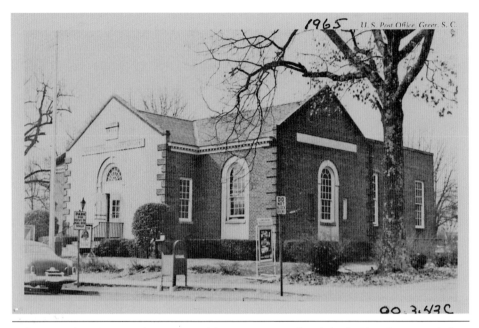

Utilizing Works Progress Administration labor, the U.S. Postal Service built this post office on South Main Street for Greer in 1935. It was used until 1959. The post office then moved to a new facility on North Main Street, and the City of Greer purchased this building for its city hall. In 2008, the new city hall opened, and this building became the Greer Heritage Museum. (Then image courtesy of Greer Heritage Museum.)

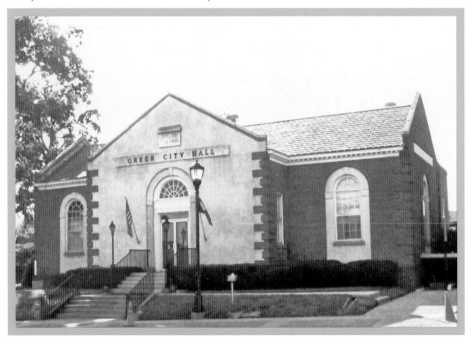

SCHOOLS AND INSTITUTIONS

After the 1913 Pelham Mill School burned, the community built a new school in 1916 with four classrooms and two stairways leading to an auditorium. Shown in this picture is the student body in the winter of 1917. This building was torn down after a new school was built in 1955. Today Pelham First Baptist Church is located on the site where both schools once stood. The present church was built in 1979. (Then image courtesy of Dot Howard.)

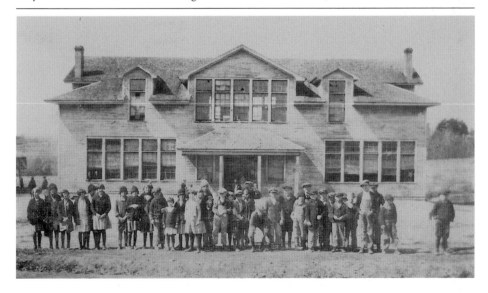

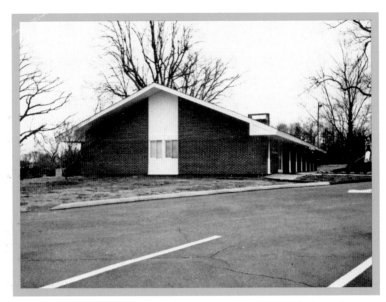

The community of Pleasant Grove established a school before the Civil War. During the 1883–1884 term, Pleasant Grove had 36 students. The public school was supplemented with private subscription in 1897. Prof. W. L McCorkle was principal; J. H. James was the chairman of the board of trustees.

The 1920s photograph shows the original school. Where it stood, the Pleasant Grove Baptist Church built its Fellowship Hall in 1965 and continues to use it today. (Then image courtesy of Mary Robertson.)

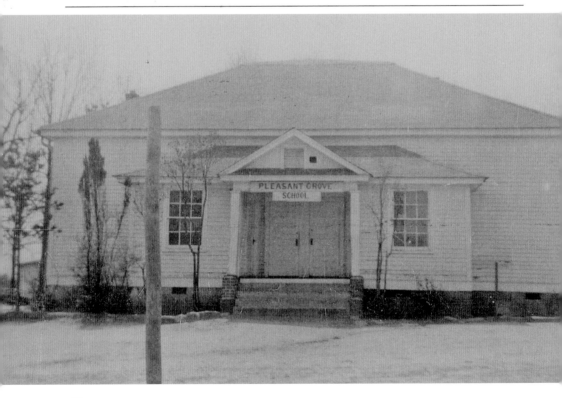

SCHOOLS AND INSTITUTIONS

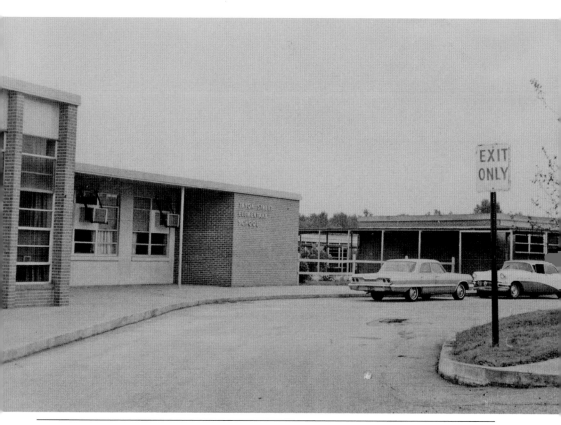

Tryon Street Elementary School was built in 1960 and was used until 1999. Located along Wade Hampton Boulevard, the school property had a prime commercial location. After the Greenville County School district sold the property, developers began marketing the land for commercial development. In December 2006, SunTrust Bank built its new branch where the school once educated the children of the west end of Greer. (Then image courtesy of Greer Heritage Museum.)

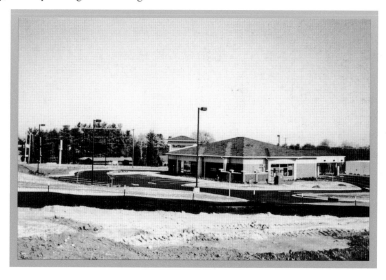

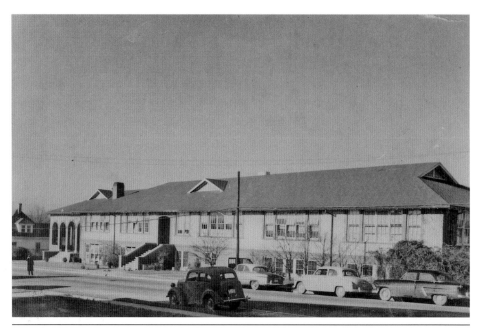

Victor Mill, which began operation in 1896, had a mill school under construction by 1900, and classes began no later than the next year. Lewis Parker, president of Victor Manufacturing Company, funded the school $100 above the annual funding for comparable public elementary schools. The school (shown above) was closed in 1972. Victor Baptist Church built its family life center (shown below), but sold it to the City of Greer to be used as a community recreation center. (Then image courtesy of Greer Heritage Museum.)

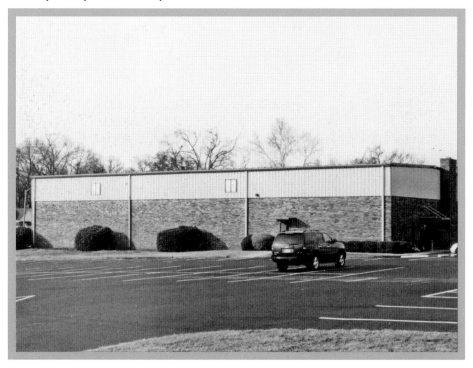

SCHOOLS AND INSTITUTIONS

By 1920, Greer had outgrown its school, and some classes were held in upstairs rooms of downtown businesses. When D. D. Davenport died in 1918, he had left money in his estate for a new high school. Davenport High School on West Church Street was completed in 1922. It became the junior high school when the new Greer High School was built on North Main Street in 1952. On February 1, 1970, the school burned. Today duplexes sit on the old school site. (Then image courtesy of Greer Heritage Museum.)

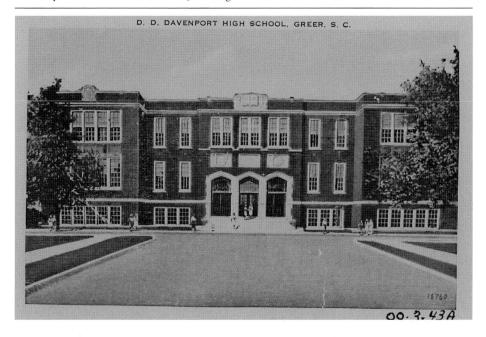

D. D. DAVENPORT HIGH SCHOOL, GREER, S. C.

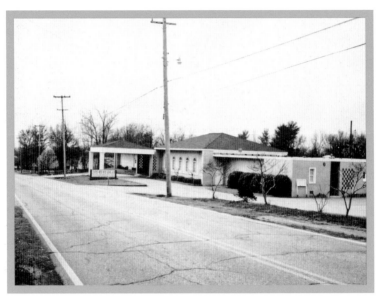

Fairview Elementary was an early school that originally served the mostly rural Fairview community. As Greer grew, it became part of the Greenville County School System, providing an elementary school for the north side of town. The vintage picture shows the school after an addition to update the older structure. When it closed in 1983, a church purchased the property and removed the old part of the building. Today the Greenville First Korean Baptist Church worships in the facility. (Then image courtesy of Greer Heritage Museum.)

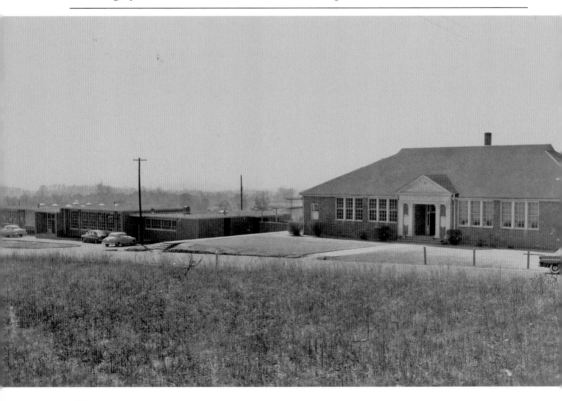

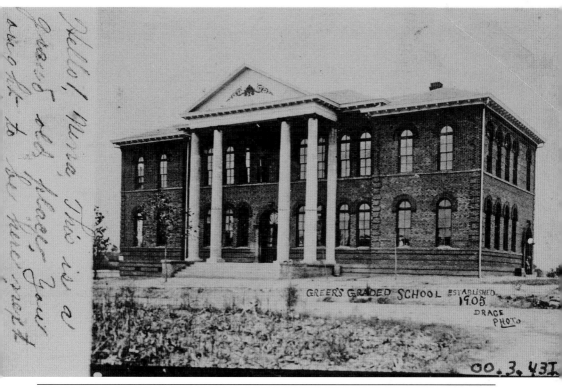

GREER'S GRADED SCHOOL ESTABLISHED 1905

DRAGE PHOTO

OO.3.431

In 1905, on School Street, Greer opened a fine new school building that was designed by Thomas Keating and cost $9,000. J. M. Moore, the principal, also became the first superintendent of city schools. Within five years, the school was overcrowded, and contractor J. C. Cunningham added four additional classrooms. Known later as Central, the school burned in 1960. The First Presbyterian Church purchased the land and built a family life center in 1969, adding the gymnasium shown here in 1983. (Then image courtesy of Greer Heritage Museum.)

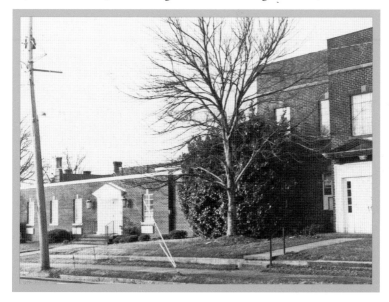

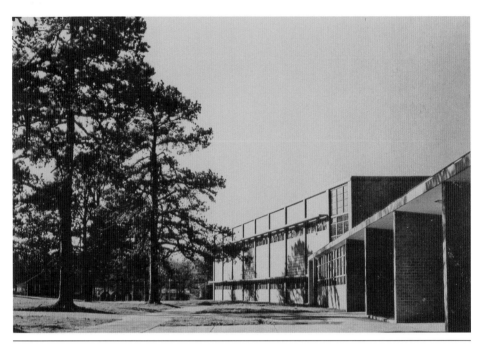

Greer High School was built in 1952 and was dedicated on March 8, 1953. The auditorium visible in the modern picture was added in 1957. Today the building is the J. Harley Bonds Career Center, a vocational high school offering automotive, carpentry, and other skilled programs. The Greer Learning Center, a satellite of the Greenville Literacy Association, uses the second floor, while the community theater uses the auditorium. (Then image courtesy of Greer Heritage Museum.)

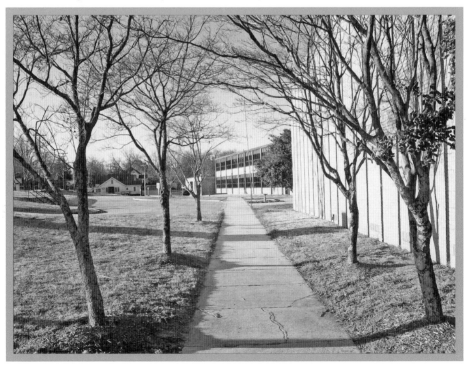

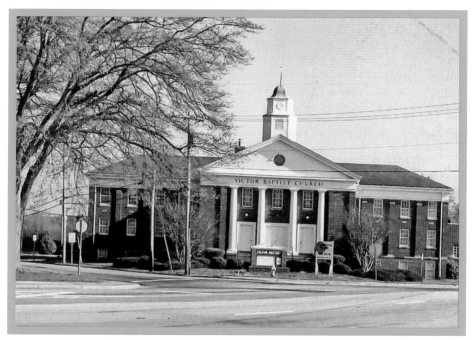

In 1909, a YMCA was organized at Victor Mills, and a larger building was planned to replace a meeting house known as the welfare building. The YMCA of Victor Manufacturing Company was dedicated on March 29, 1911. It had meeting rooms, classrooms, a gymnasium, electricity, and modern plumbing. The building was only the 10th such building in the Carolinas. On this site today is the former Victor Baptist Church building, which is for sale. (Then image courtesy of Jerry Jackson.)

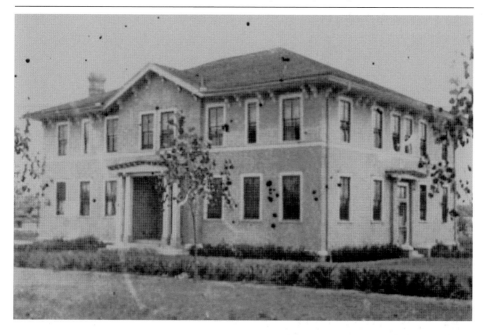

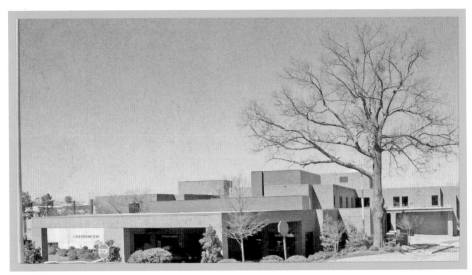

Allen Bennett Hospital opened on May 1, 1952, on the corner of Memorial Drive and Wade Hampton Boulevard. B. A. Bennett donated the land and named the 27-bed hospital in memory of his son Dr. B. Allen Bennett Jr., who died in World War II. Several additions over the years increased the size of the hospital, as seen in the picture of the current facility. In 2008, the hospital closed and relocated its services to the new Greer Memorial Hospital on South Buncombe Road. (Then image courtesy of Smith Library.)

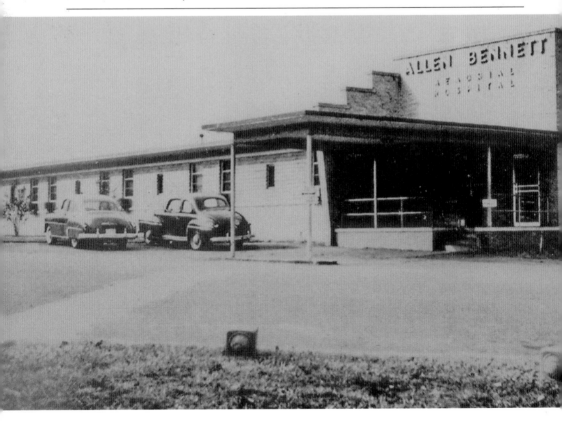

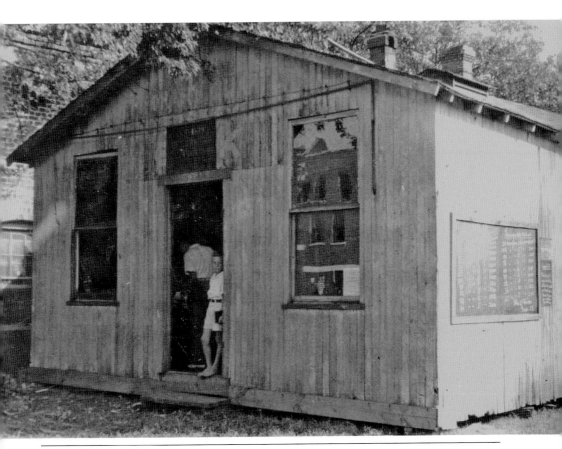

The Civitan Club opened the Greer Public Library on November 18, 1925, in the building that the chamber of commerce used until it disbanded. In 1926, it became the first branch of the Greenville City Library and used the one-room, white-washed building until 1938. Today the Greer Fire Department and Police Station occupies the site of the former library and chamber building. (Then image courtesy of Smith Library.)

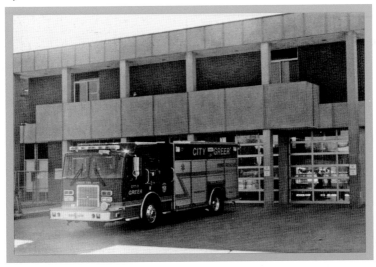

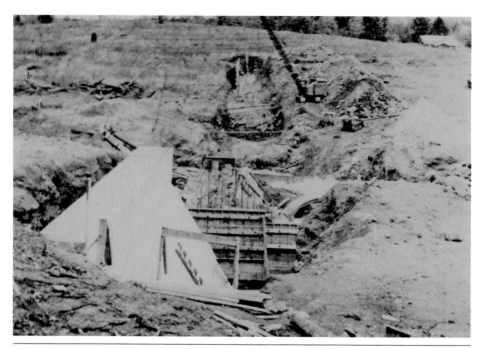

The dam across South Tyger River, shown here under construction, was completed during the late 1950s and provided Greer's first permanent reservoir. Previously, water had been pumped directly from the river. Lake Cunningham added a recreational dimension and encouraged realty sales along the shores of the new lake. The dam has been supplemented by a newer and larger construction spanning the same river a few miles north. Today the older dam rests under a security watch mandated by Homeland Security regulations.

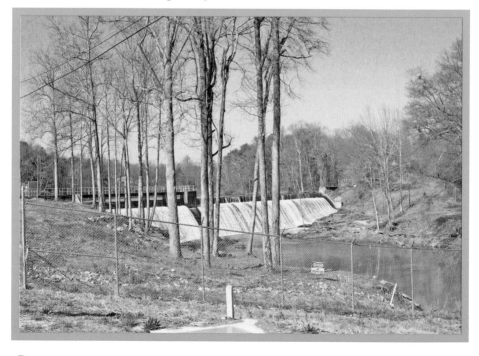

Anyone who parks in the lot in front of the old P&N Depot may not realize that, at one time, the fire and police stations occupied the spot. In this 1955 picture, squatting down on the left is Parks Boozer, who was later the police chief. The fourth man from left (in uniform) is Cleo Center. On the far right is councilman Worth Barnett, later the mayor. Fire chief Broughton Colvin is on the right truck, dressed in his uniform with his badge. (Then image courtesy of Beatrice Whitman and Henry Sammons.)

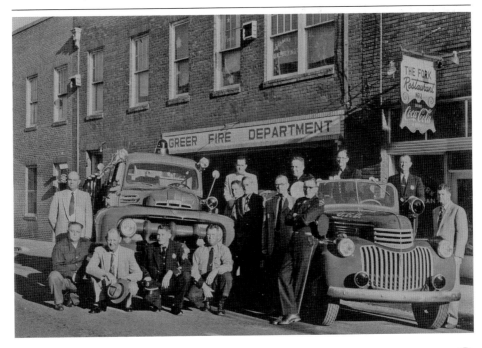

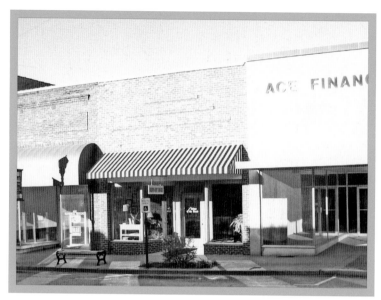

The building beside Marchant's Greer Drug Company served as the Greer Post Office from 1885 until 1911. From 1900 to 1912, W. Ennis James served as the postmaster. The post office building received a face-lift in the 1970s and, most recently, served as a loan company. The building beside it that is home to Trims on Trade, a styling salon, was once a grocery store.

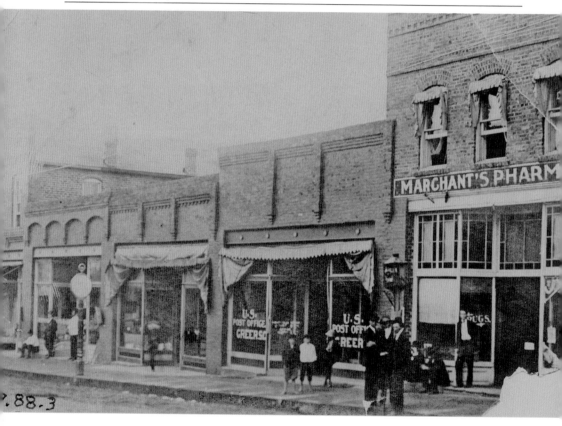

CHURCHES

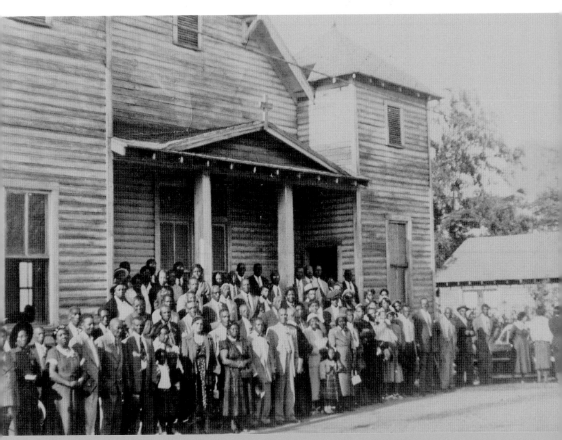

Bethesda Temple was built in the African American community of Sunnyside on Broadus Street behind Dunbar School. The church continues today in a new building that was built beside the one shown. The site of the original building is now the parking area for the church. (Courtesy of Marshall James.)

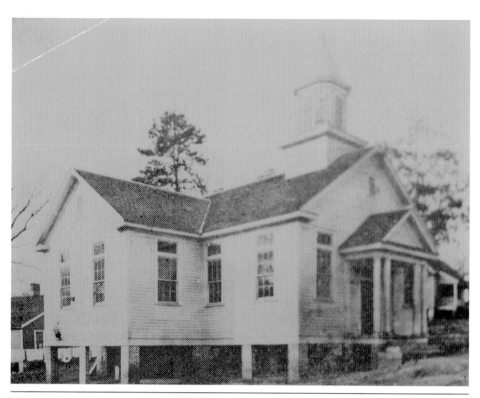

The Apalache Baptist Church began as a union church sharing space with the Methodists. In 1924, the congregation built a wooden building (shown above) and used it until 1941, when fire destroyed it. The brick church was dedicated in July 1941, and several additions were made during the next three decades. Apalache Baptist relocated to Gap Creek Road in 1999 and no longer uses this facility. The building is now used by New Covenant Fellowship.

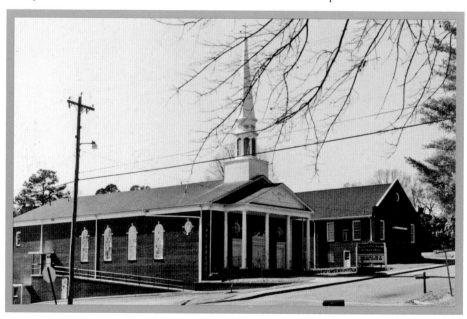

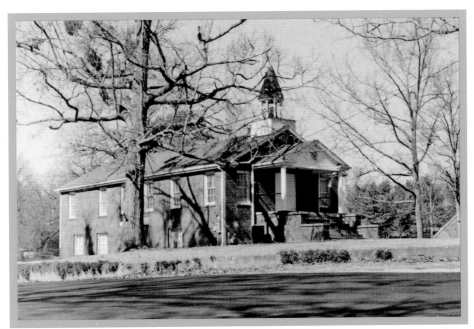

The Apalache Methodist Church began as a union church in 1902 and worshipped in various locations until May 1924, when the congregation purchased the frame church (below) from the mill. In 1950, the congregation decided to build a new church. The old building was torn down, and the new brick church was built. Much of the work was done by members, and on October 19, 1952, the new church was dedicated. The congregation disbanded in 2008.

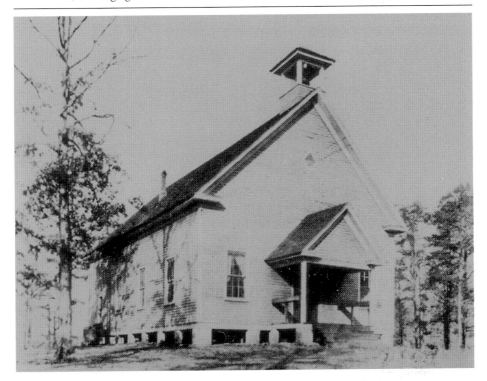

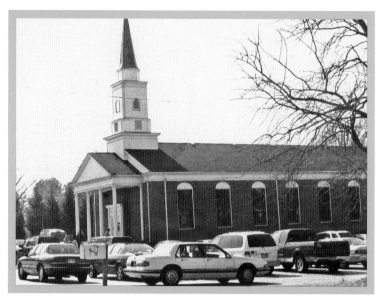

Calvary Baptist Church was organized on May 8, 1949, and met in the home of Troy Webb until a church (shown in the 1950 picture below) was built by the members in just a few months. A brick educational building was completed in 1966. Church growth mandated a new sanctuary to replace the frame building. A new one, still used today (pictured above), was dedicated in 1972. Pastor Gene Turner and his family have served the church since 1970. (Then image courtesy of Gerald Davis.)

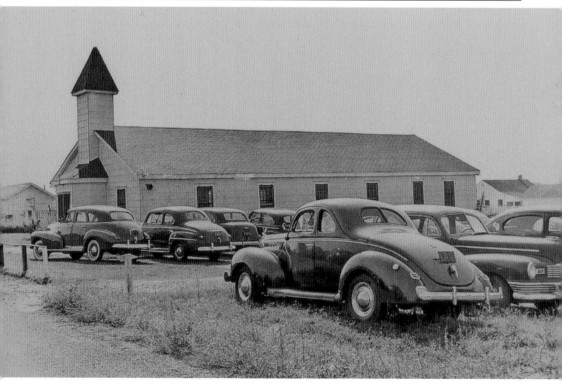

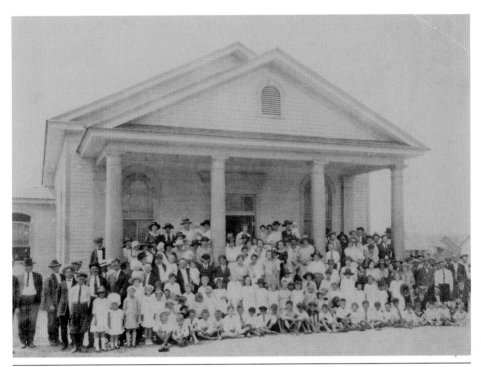

When the Methodists in the Greer Mill village organized in 1911, they shared the union church with the Baptists. In 1921, the Methodist congregation built a church on the corner of Connecticut Avenue and Duke Street. The 1922 picture shows the congregation in front of the new church. A 1945 renovation added three classrooms, a kitchen, and an assembly hall. In 1955, a brick veneer was added, and the facade was updated to the look seen in the modern picture. (Then image courtesy of Ann Withrow.)

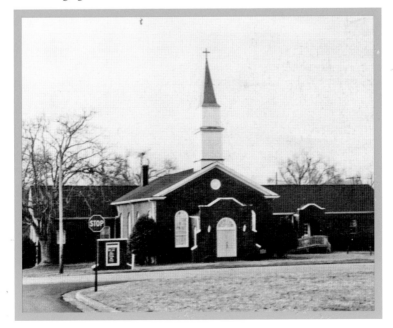

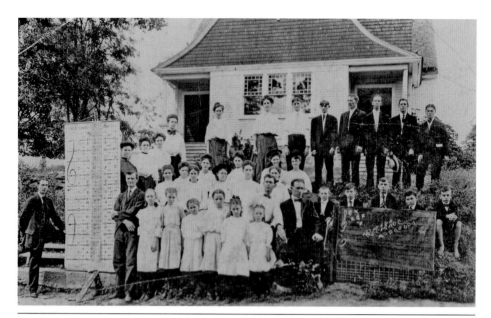

Corinth Church was the Pelham Mill union church, used by both the Baptists and the Methodists. Posing in front of the church is the Singing School. On the first row at far left, behind the chart is the music teacher, Robert Boling, and to the right of the chart is the minister, Reverend Coleman. In 1908, this building burned. The Pelham Baptist Church erected a brick building in 1941 and used it until 1979. The Church of God of Prophecy used the facilities after the Baptists until the widening of the highway rendered it inaccessible. Today the building stands empty and full of memories of songs and sermons. (Then image courtesy of Dot Howard.)

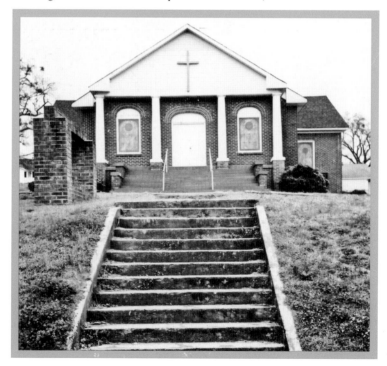

El Bethel traces its beginnings to the 1911 union church built by the Greer Manufacturing Company. The congregation named the church El Bethel in 1915 and, the next year, paid the Methodists for their share of this building on the corner of Connecticut and Bob Streets. In 1951, the congregation built a new building on the corner of Pennsylvania Avenue and Parker Street. The old building was torn down, and the land was returned to the textile mill. An addition to the mill covers the site today.

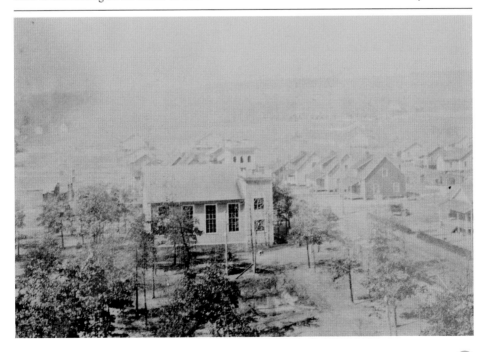

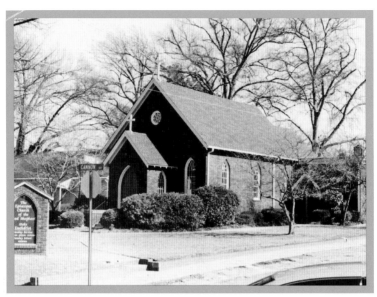

The Greer Episcopal Church of the Good Shepherd was organized in 1913, and early meetings were held in homes of the founders. No building seemed possible at the time, and meetings were suspended until the 1920s. In 1930, the Episcopal Diocese of Upper South Carolina purchased a lot on the corner of Cannon and Jason Streets. The church consecrated its new building on May 18, 1932, and continues to use it today.

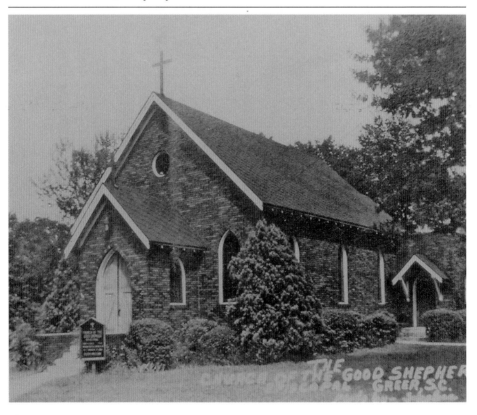

In 1887, on the bank of Maple Creek, the Reverend W. B. Chainey and Brother David Holtzclaw took a cross-cut saw and cut a maple tree to the height of a pulpit. The worshippers sat on an upturned wagon. This was the beginning of the church that would be called Maple Creek Baptist. In 1891, the congregation moved to its present location on South Main Street. The small old church (shown above) was replaced with a larger, modern facility (pictured below).

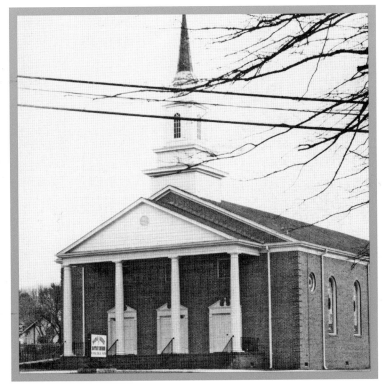

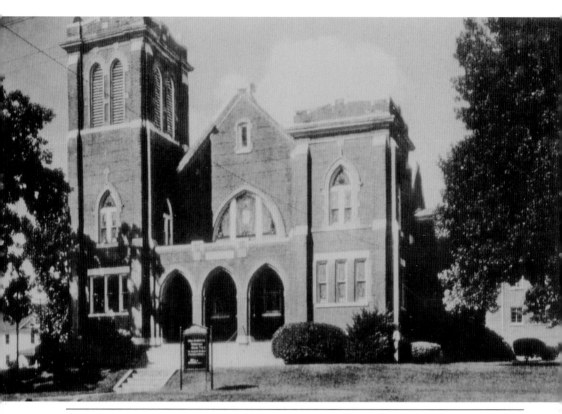

Greers Methodist Church began in 1882. In 1907, the church started a new building, and the brick church shown was completed in 1908 on the corner of North Main and Church Streets. In 1922, the church changed its name to Memorial United Methodist Church. The current building (shown below) was constructed in 1956 to replace another facility that had burned down not long after it was built.

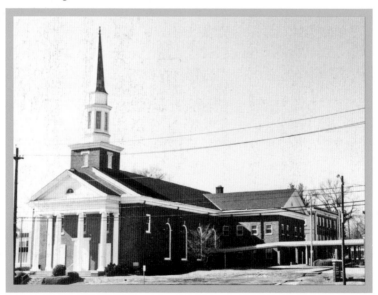

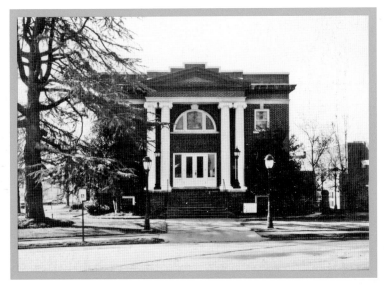

Mount Tabor Presbyterian Church was organized in 1840 in the Pleasant Grove community. After Greer incorporated in 1876, W. T. Shumate, who had subdivided the downtown land, donated this location along South Main Street for the church. In 1880, Mount Tabor moved the little wooden church to town on logs. Renamed the First Presbyterian Church, the current church (shown) was built in 1923, after the old church was razed in 1922. (Courtesy of Greer Heritage Museum.)

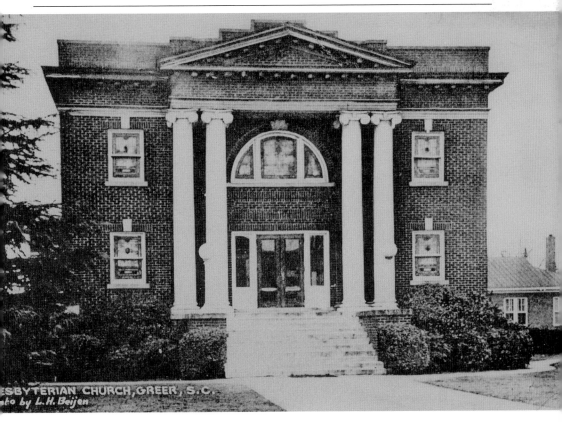

ESBYTERIAN CHURCH, GREER, S.C.
to by L. H. Beijen

ACROSS AMERICA, PEOPLE ARE DISCOVERING SOMETHING WONDERFUL. *THEIR HERITAGE.*

Arcadia Publishing is the leading local history publisher in the United States. With more than 3,000 titles in print and hundreds of new titles released every year, Arcadia has extensive specialized experience chronicling the history of communities and celebrating America's hidden stories, bringing to life the people, places, and events from the past. To discover the history of other communities across the nation, please visit:

www.arcadiapublishing.com

Customized search tools allow you to find regional history books about the town where you grew up, the cities where your friends and family live, the town where your parents met, or even that retirement spot you've been dreaming about.